Stonehenge

the eternal mystery in pictures

Stonehenge

the eternal mystery in pictures

ENGLISH HERITAGE

First published in 2006 by

English Heritage Kemble Drive Swindon SN2 2GZ

© English Heritage 2006

Packaged by Susanna Geoghegan

Text copyright © Julian Richards

Design by The Design Factory Limited

ISBN 1850749671

Product Code 51094

Printed in Singapore by Imago Publishing

INTRODUCTION

Stonehenge is unique, there is nothing like it anywhere else in the world. Today, nearly a million people a year come to brooding, wind-swept Salisbury Plain and marvel at the henge's great age, the size and arrangement of its iconic stones and the extraordinary ingenuity of its prehistoric builders.

But a million visitors a year would not have come to see the first Stonehenge, constructed around 3000 BC. That was a simple circular ditch, arduously dug out of the Wiltshire chalk with picks fashioned from red-deer antler. The chalk was piled up just inside the inner edge of the ditch to make a low bank.

Together, the bank and ditch would have gleamed bone-white against the green of the natural vegetation. At first this enclosure had two entrances but the one facing north east gradually became the most important, remaining so throughout the ages and, indeed, is the one that we can see today. Mysterious timber structures were built inside this first Stonehenge and the cremated bones of the dead were buried both in the ditch and in the holes left by rotted timbers.

Then, four or five hundred years after the ditch was dug, a remarkable transformation of the site began. The first stones arrived, pillars of so-called

'bluestone' from the Preseli Mountains in Wales, a staggering 125 miles from Stonehenge. These were soon followed by the massive sarsens, great slabs of stone from the Marlborough Downs about 20 miles to the north. From this point the structures that we see in ruins today started to take shape.

Outside the entrance lies a single unworked sarsen known as the 'Heel Stone'. To one side of the entrance causeway lies the so-called 'Slaughter Stone', its name the result of lurid Victorian imagination, that saw the blood of sacrificial victims in the puddles of reddish water which collect on its surface.

Close to the inner edge of the bank lie two small sarsens – the 'Station Stones' – which, like the Heel Stone and the Slaughter Stone, originally had companions which disappeared long ago.

But it is the stones in the centre, the ruins of the magnificent building that is Stonehenge, that have always attracted the most attention, speculation and wonder.

Starting from the outside, the first part of the structure is a circle of massive sarsens that would have originally contained no less than 30 uprights capped by 30 horizontal stone lintels. This itself is remarkable considering that the stones, weighing up to 30 tons each, had been dragged a distance of 20 miles. But what is far more

remarkable, and unique to Stonehenge, is the way in which these colossal stones have been shaped and jointed together. On the top of the uprights are protruding lumps, or tenons, that fit into corresponding holes, or mortices, on the underside of the lintels. And, as if this wasn't enough, the ends of the lintels, each of which is gently curved, are also jointed to each other. Vertical raised tongues fit into corresponding grooves to create what would originally have been a continuous ring of stone, suspended 4 metres above the ground. Despite the slope that Stonehenge was built on, the top of the circle was perfectly level.

Inside this structure lies a circle of smaller bluestones that show little

signs of working, and then, moving further towards the centre of Stonehenge, lie the great sarsen trilithons. These are the most imposing structures of all: originally five in number, like great stone doorways arranged in a dramatic horseshoe shape with the open end pointing out towards the enclosure entrance. Each trilithon, (the term comes from the Greek for 'three stones') has two uprights capped by a huge lintel. Like the sarsens of the outer circle these have been carefully shaped and the lintels lock onto their uprights with the same mortice-and-tenon joints. But these trilithons, the tallest structures at Stonehenge, are not all the same. They rise in height from the open end of the horseshoe to where the tallest of all stood proudly facing out

towards the entrance. This, the Great Trilithon, is now a ruin. Its only surviving upright, the tallest standing stone in the British Isles, is an elegant 40-ton pillar on which the tenon can clearly be seen silhouetted against the wide Wiltshire sky. Its companion stone lies shattered on the earth, close to the fallen 10-ton lintel they supported for thousands of years.

In the same way that the sarsen circle is mirrored by the bluestones, inside the sarsen horseshoe lies another that originally consisted of 19 bluestones. These are tall and carefully shaped, many into regular slender pillars. Some show signs of having been used as the components of smaller bluestone trilithons before being set upright. And finally at the base of the

Great Trilithon, lies the huge, enigmatic Altar Stone, the largest of the stones transported all the way from distant Wales. It now lies beneath the ruins of the fallen trilithon, but whether it stood upright as a pillar or really served as an altar, lying flat on the ground, remains one of the tantalising mysteries of Stonehenge.

These are the awe-inspiring structures that make up Stonehenge: the monumental stones, the banks and ditches of earth and chalk and the fascinating remains of long-vanished timbers which have only been discovered through painstaking excavation. In addition, from the entrance to Stonehenge a long Avenue of parallel ditches and banks stretches out into the landscape; a

landscape that has an abundance of evocative ceremonial sites and burial mounds from the time of Stonehenge and even earlier.

For centuries antiquarians and early archaeologists puzzled over the mysteries of Stonehenge – its meaning, its age and who had built it. It was generally accepted that it was some sort of a temple, but because there seemed to be elements of classical architecture in the arrangement of its stones, some suggested that it was Roman. But for those who thought it was built by the Ancient Britons, it had to be a temple of the Druids, an association that has persisted to the present day. There were real Druids in ancient times, but they did not appear until nearly 1,000 years after Stonehenge had been

abandoned by those who once congregated within its hallowed precinct. The Druids who worship at Stonehenge today first made an appearance in the 19th century.

Stonehenge was investigated by archaeologists on several occasions during the 20th century, their excavations often accompanying the restorations that saw leaning stones winched upright and set in concrete – and even the re-erection in 1958 of a complete sarsen trilithon. The scientific analysis of their findings has told us how old Stonehenge is and the order in which its components were constructed. How it was built, the methods used to move, shape and raise such massive stones can still only be guessed at. Surprisingly however recent

experiments have shown that even the largest stones can be moved on a simple sledge by a team of around 200 people.

This leaves the question of why was Stonehenge built? What impelled the prehistoric inhabitants of Salisbury Plain to put so much effort and time into constructing this amazing temple? The answer lies in the heavens. Stonehenge, like many other sites of this time all over Europe, is carefully aligned with the movements of the sun. On the longest day of the year, the Midsummer Solstice on 21 June, the sun rises just to one side of the Heel Stone. It sends shafts of light on an alignment that follows the line of the Avenue, passing through the entrance to the enclosure and finally strikes and

lights up the Altar Stone that stands at the base of the Great Trilithon. Over the years, Midsummer has become the traditional time to gather at Stonehenge. But six months later in the dead of winter, around the 21 December, comes the shortest day of the year. On this, the Winter Solstice, the sun would have set in the narrow gap between the uprights of the Great Trilithon and shone its dying rays out through the entrance and down the line of the Avenue.

So which one was Stonehenge built for, summer or winter? Celebrations may have taken place at both times of the year, and on other occasions, but the Winter Solstice may have had more meaning for the farmers who built Stonehenge and who were dependent on the well-being of their crops and animals for survival. Winter would have been a time to dread but the time when the seasons changed, when days stopped getting shorter and colder and people could look

forward to the return of light, warmth and life, must have been of huge importance and a time to celebrate.

Stonehenge today is a magnificent ruin, a symbol of ancient achievement and a testament to the skills of our distant ancestors. It remains a place of great mystery and, in its simple yet powerful structures, a place of haunting beauty.

Text by Julian Richards

The arrow on each plan of Stonehenge indicates the approximate position of the photographer when the picture was taken.

Stonehenge from the north east with the Slaughter Stone in foreground

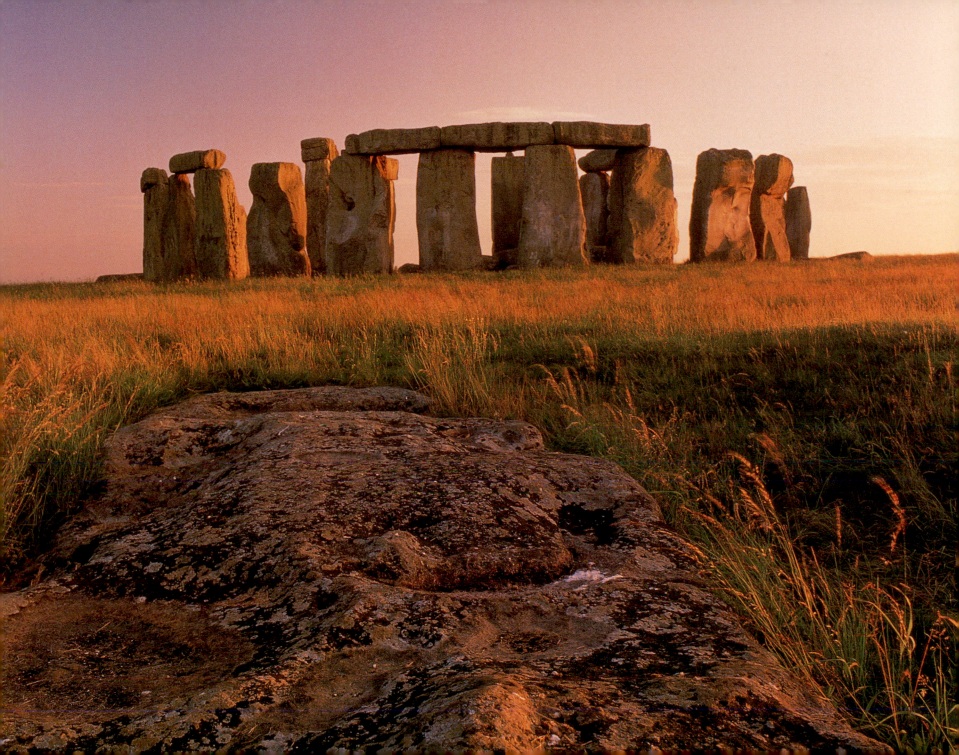

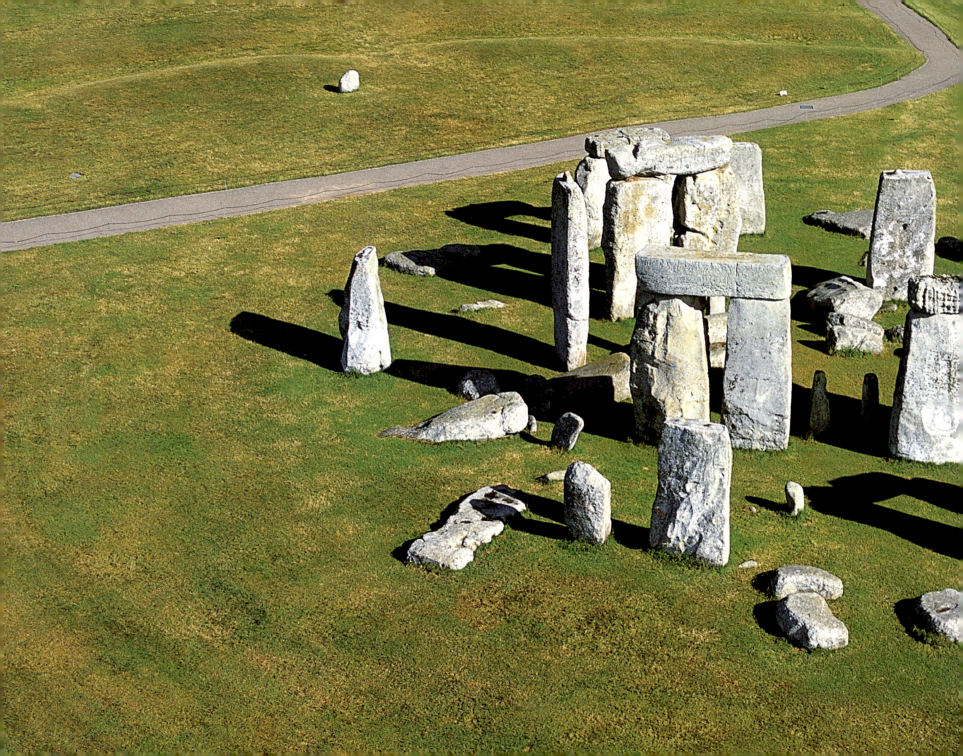

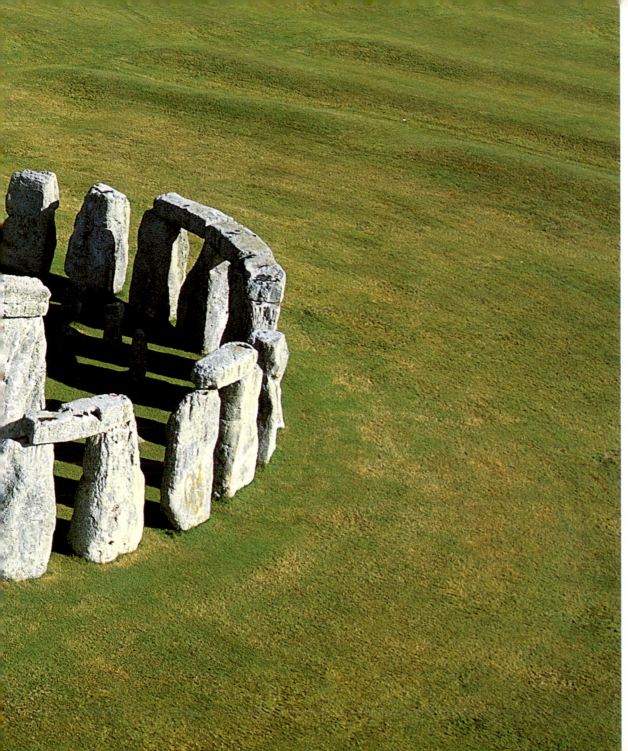

A deserted Stonehenge

Aerial view of the stones

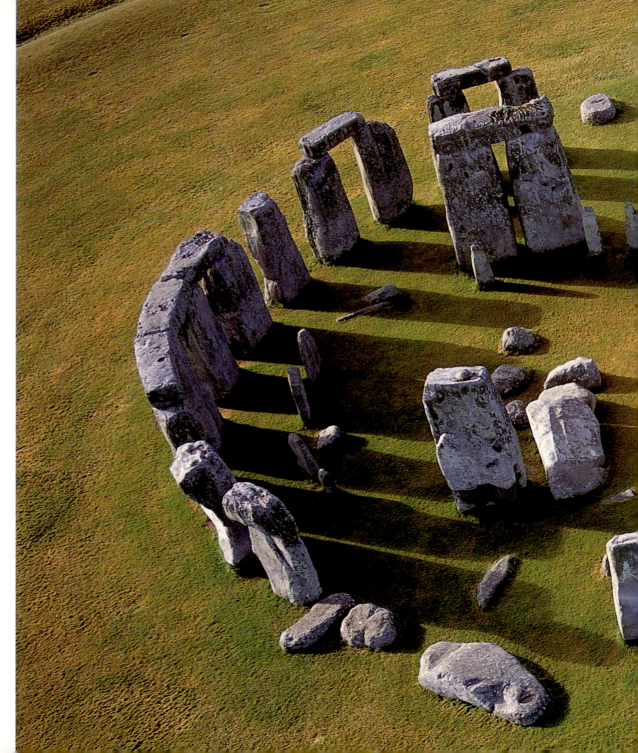

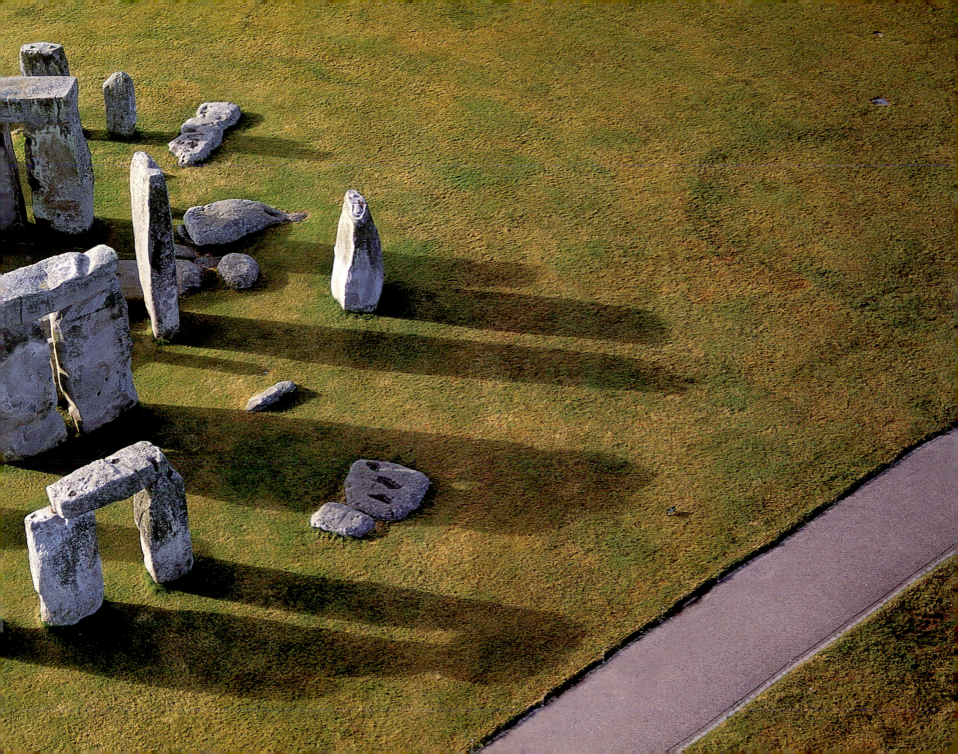

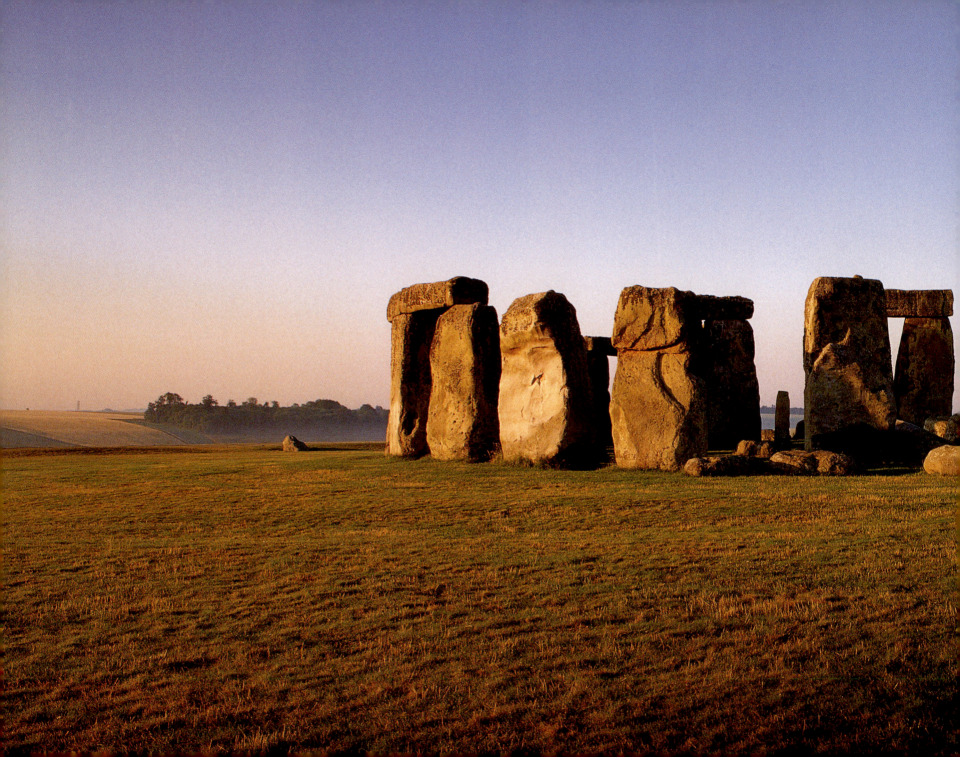

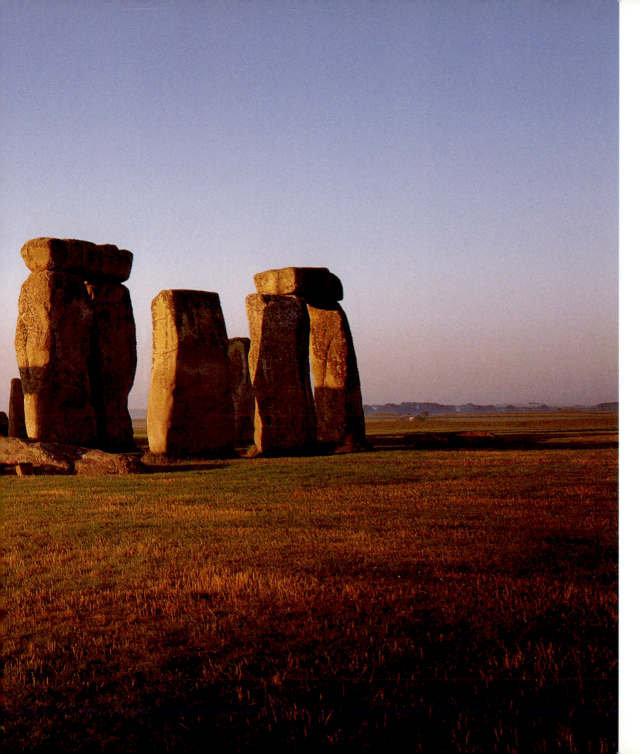

General view

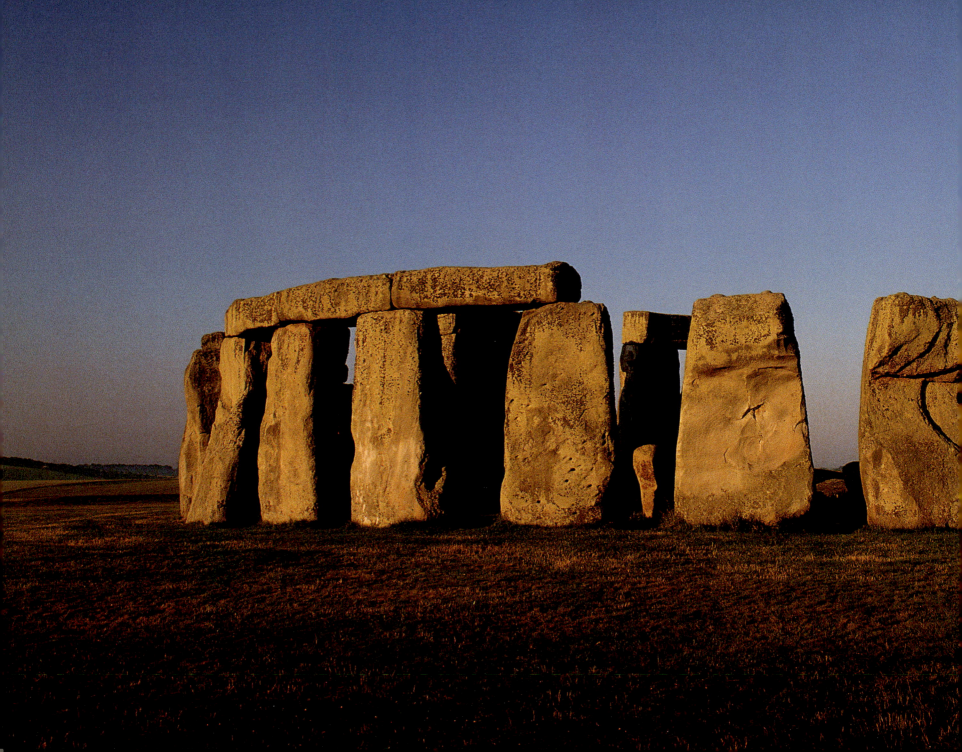

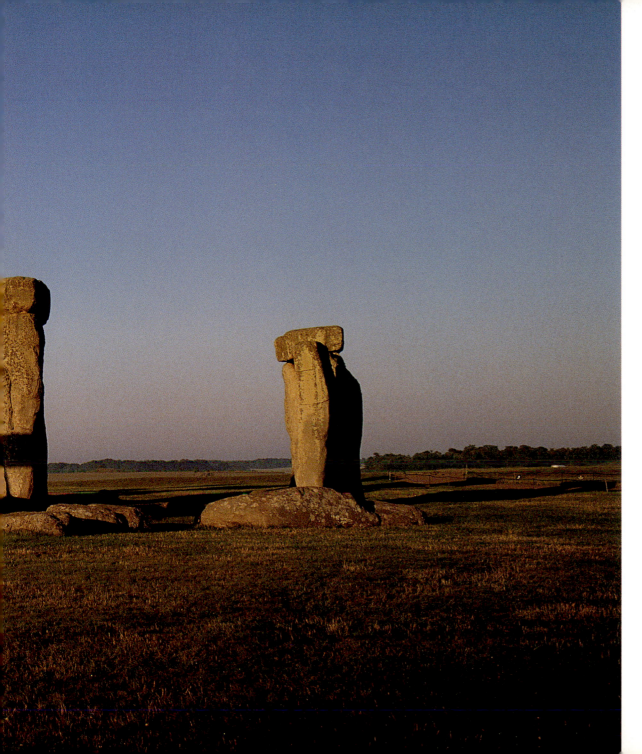

General view in evening light

In silhouette at sunset

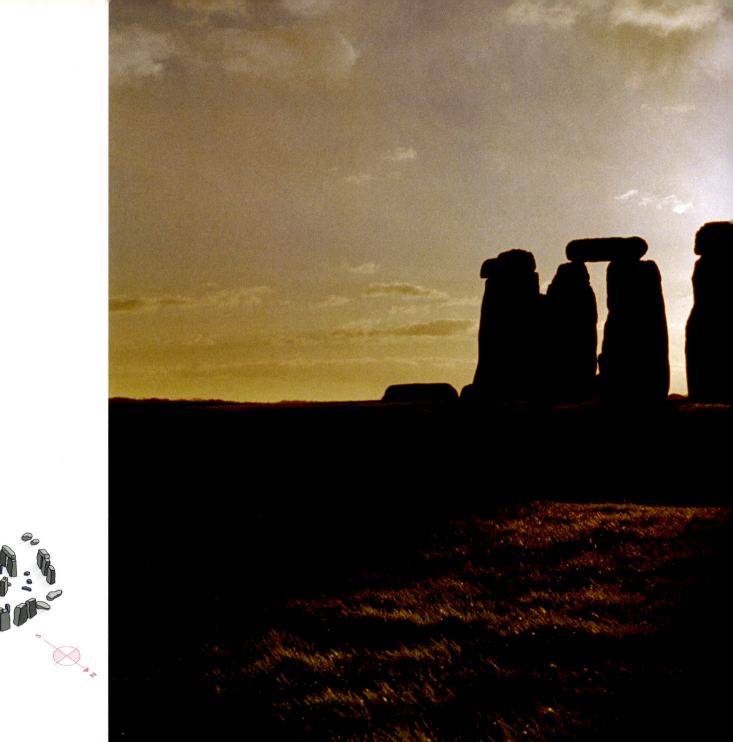

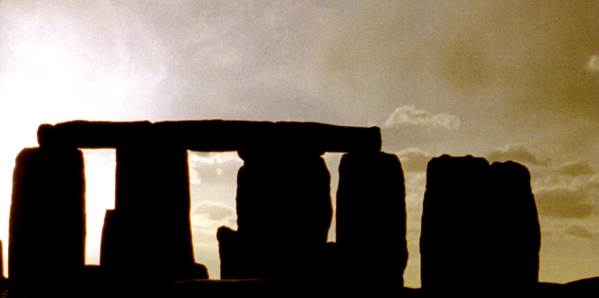

In low light with the Heel Stone
to the left

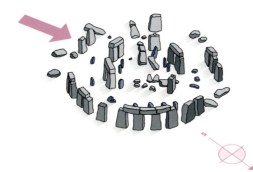

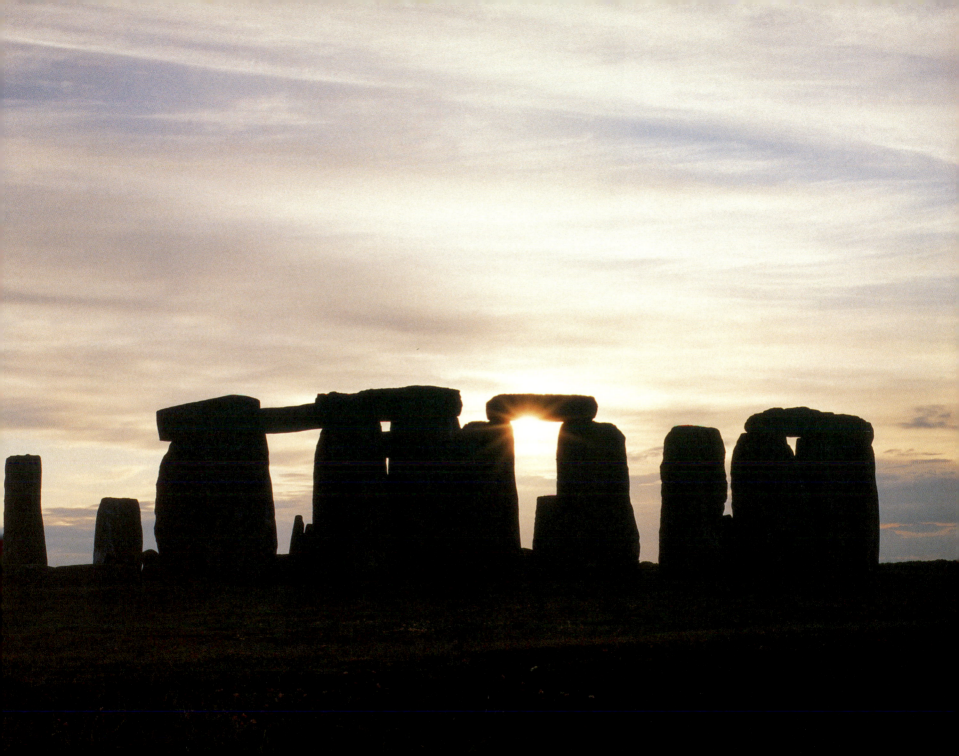

General view with one of the Station Stones in the foreground

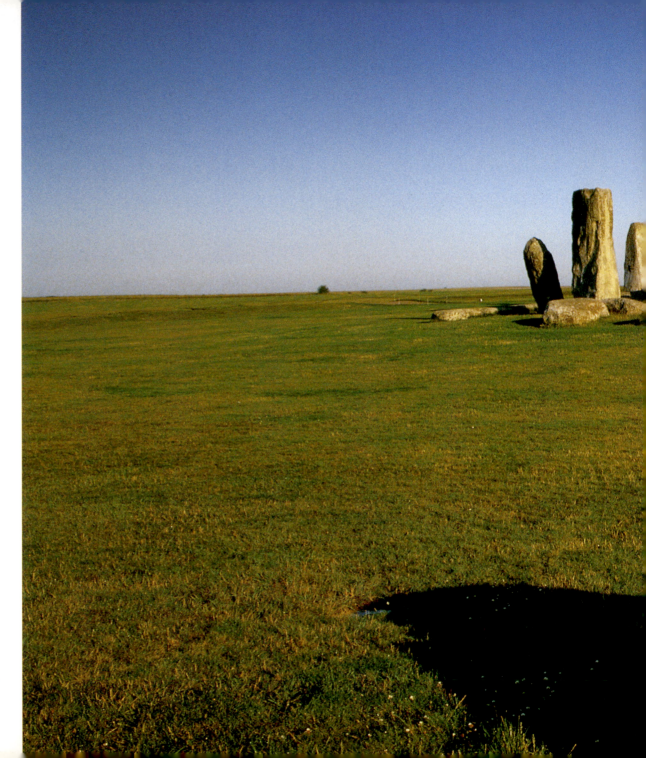

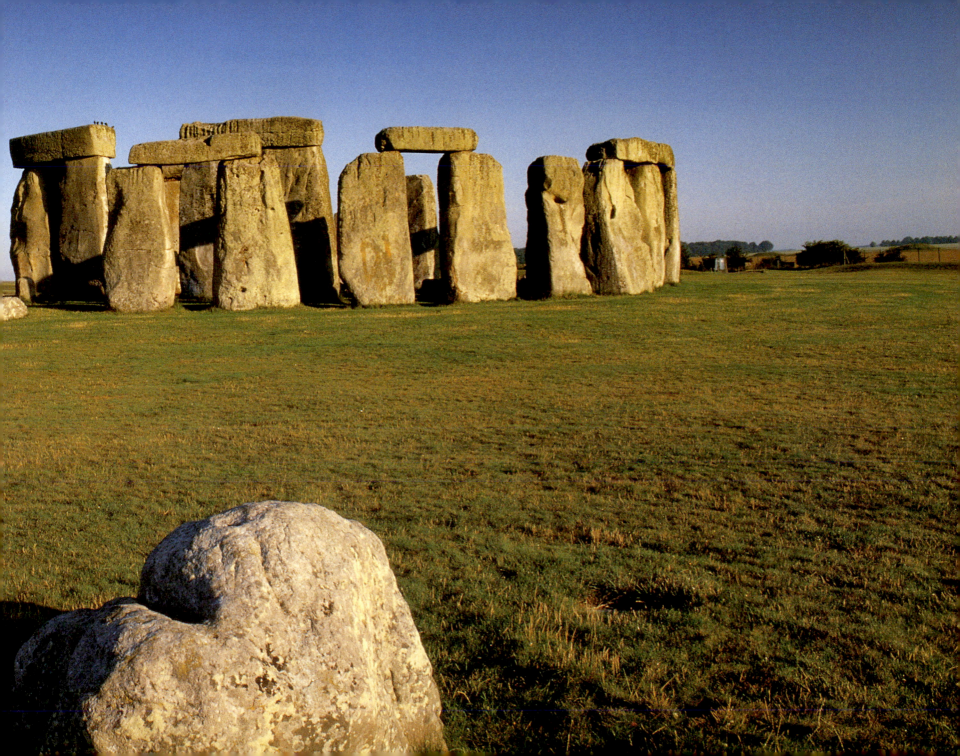

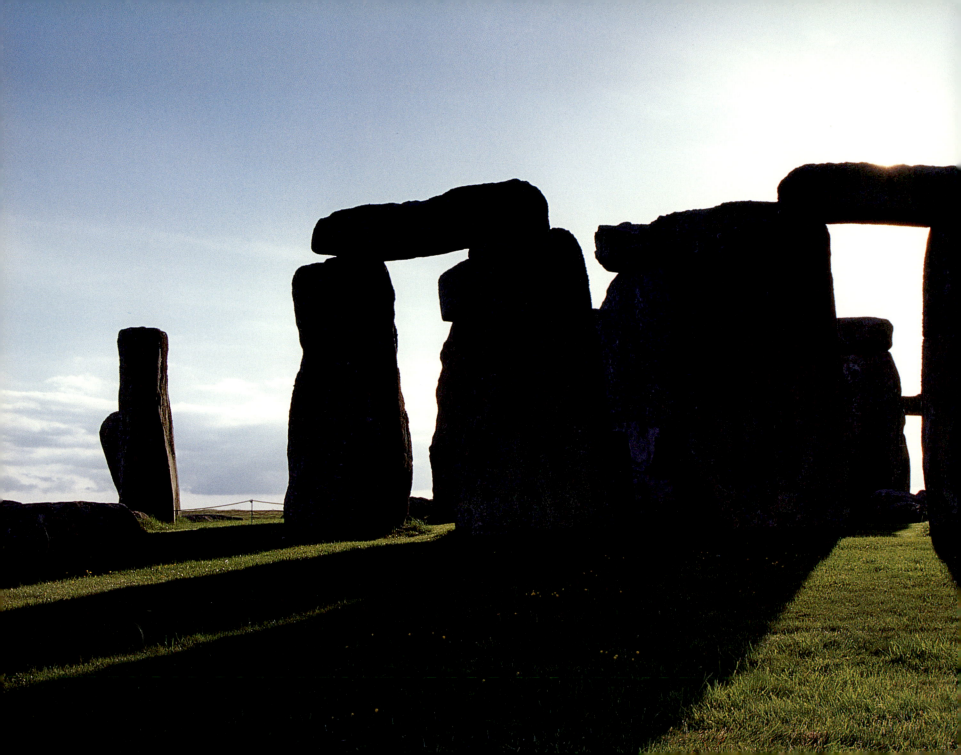

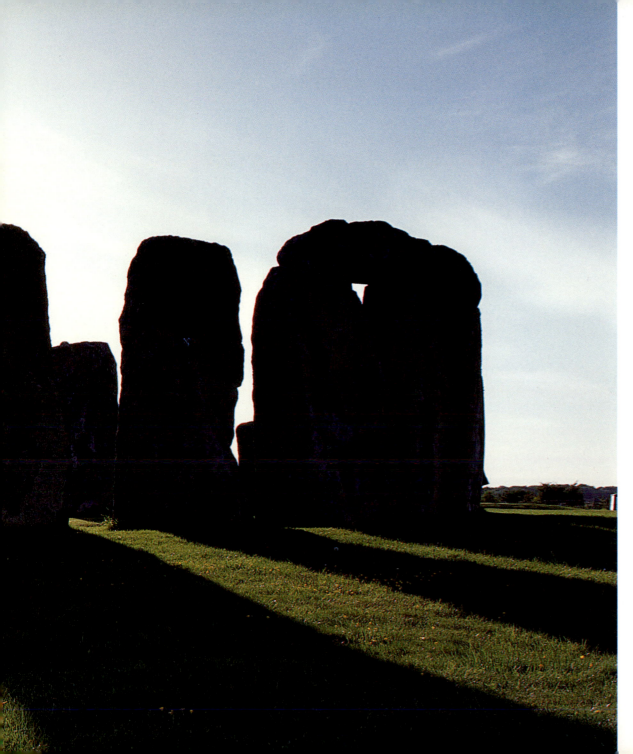

At summer sunset

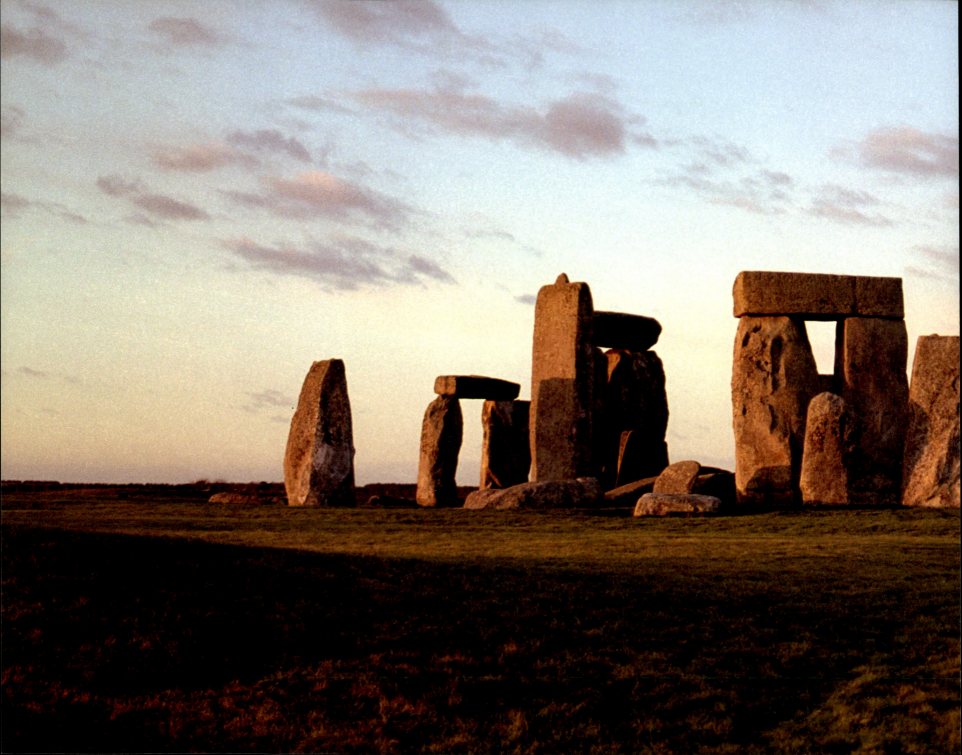

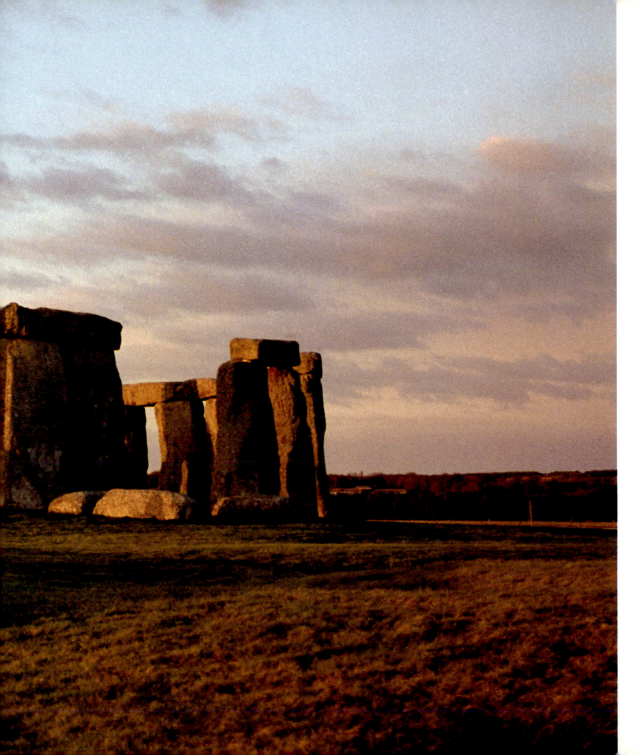

General view in fading sunlight

Captured in silhouette as the mist
rises and the sun sets

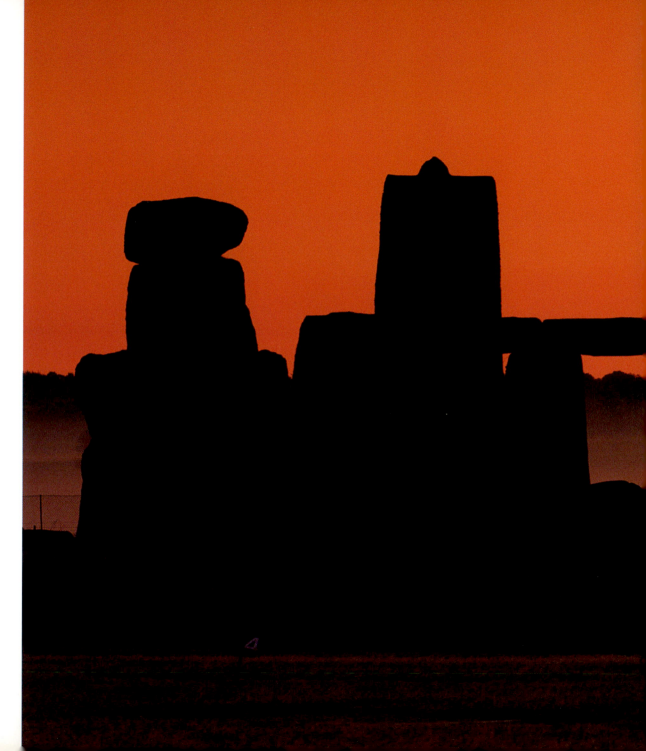

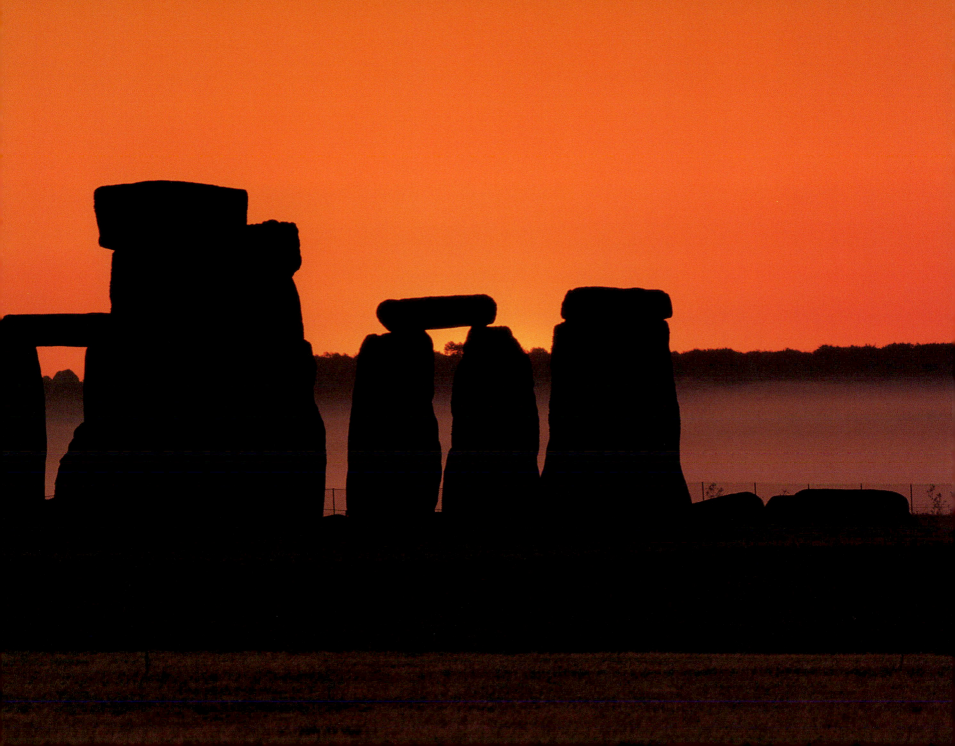

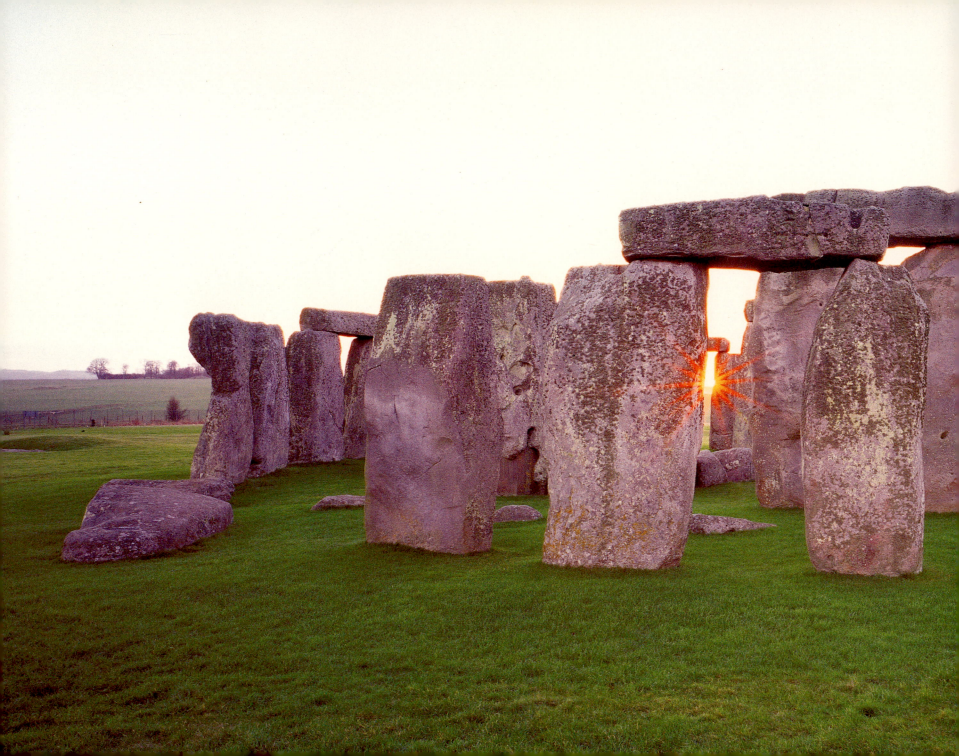

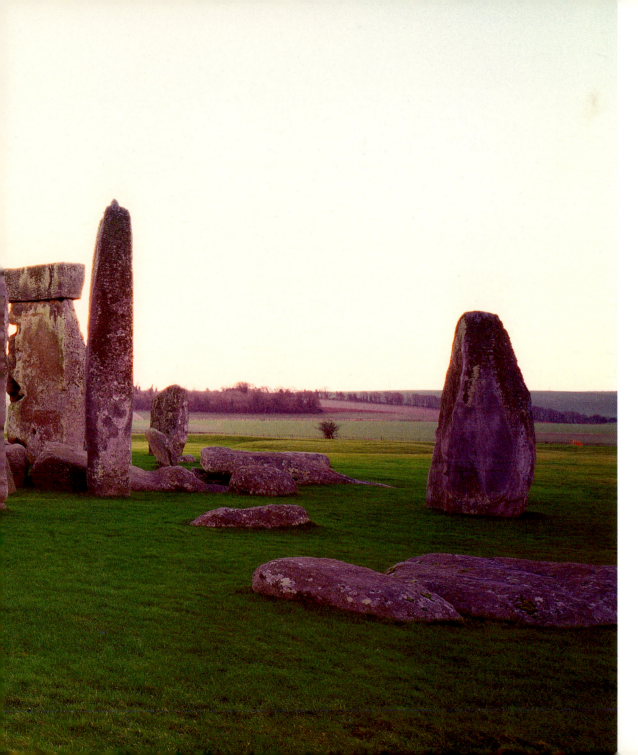

In the cold light of sunrise

Among the stones

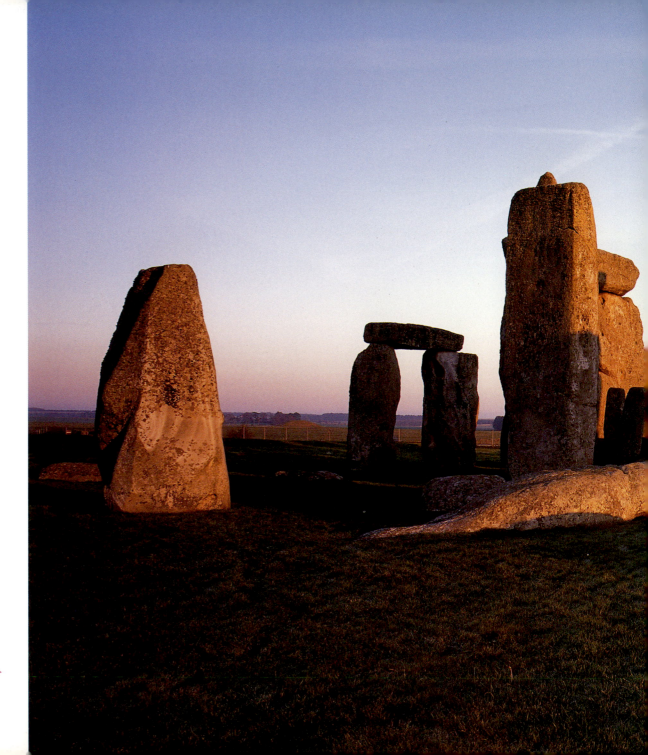

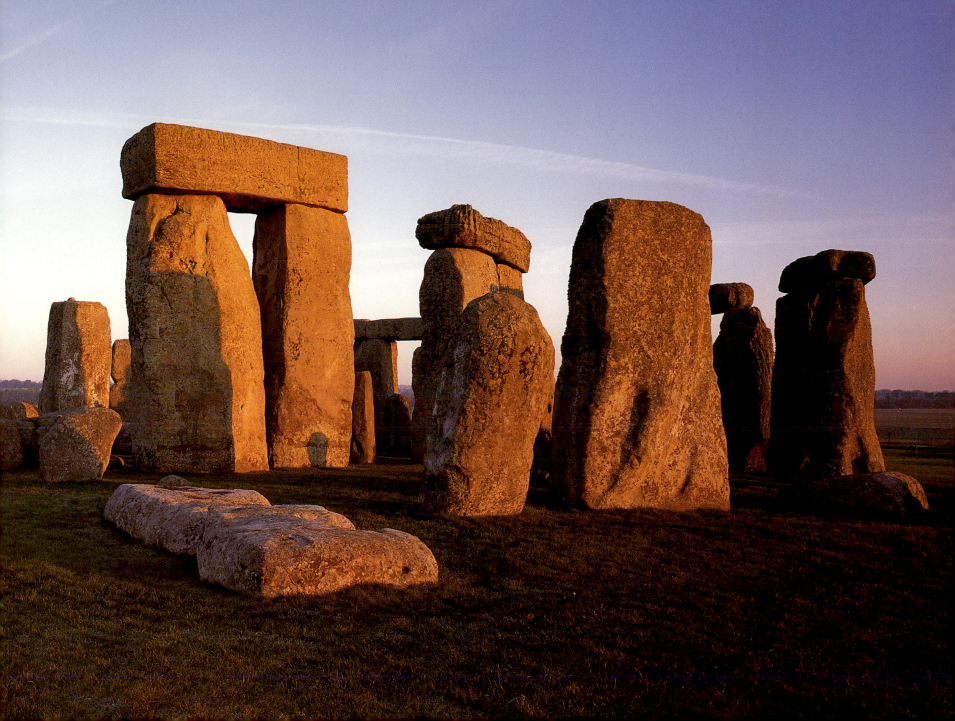

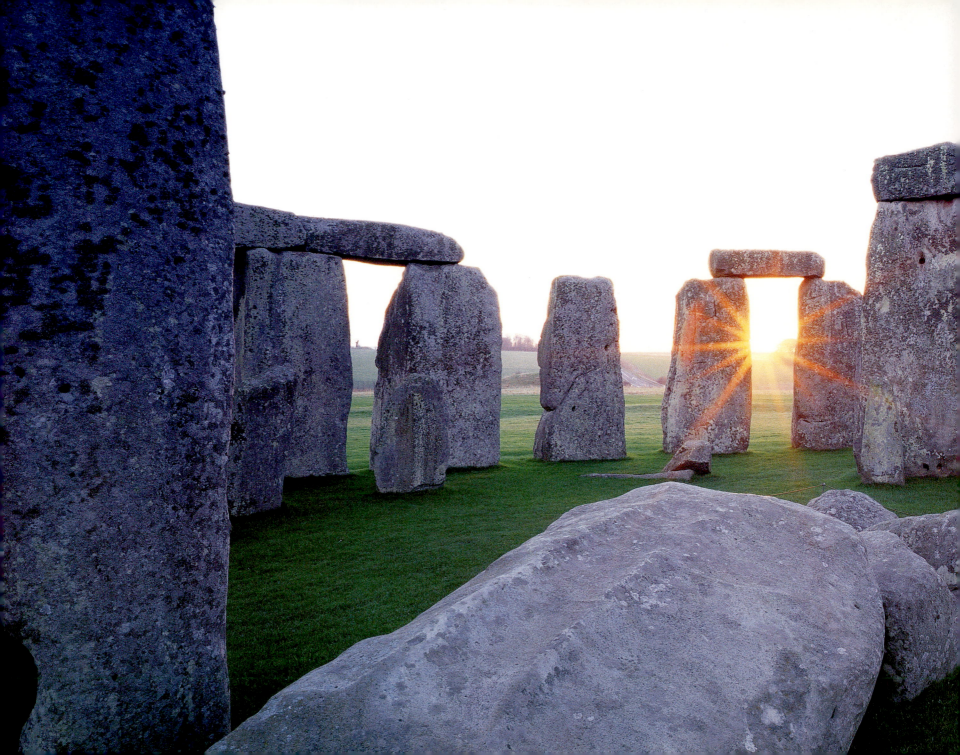

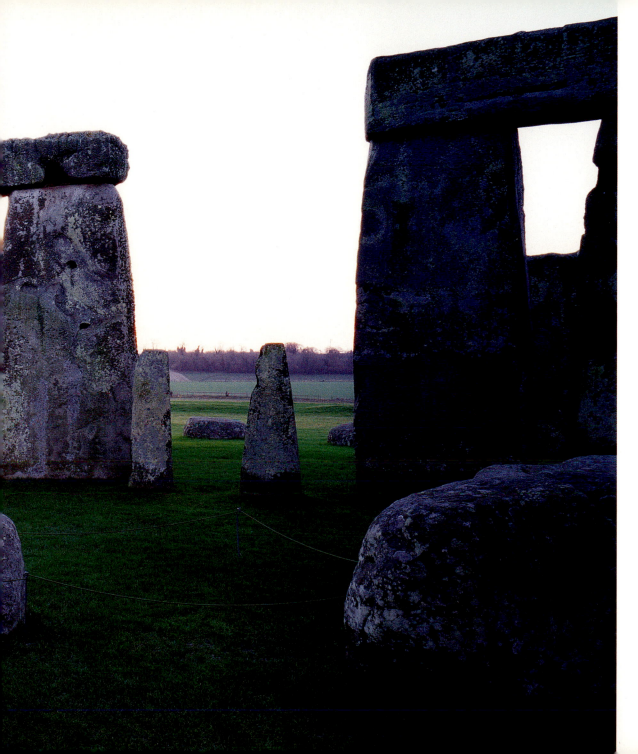

Among the stones at sunrise

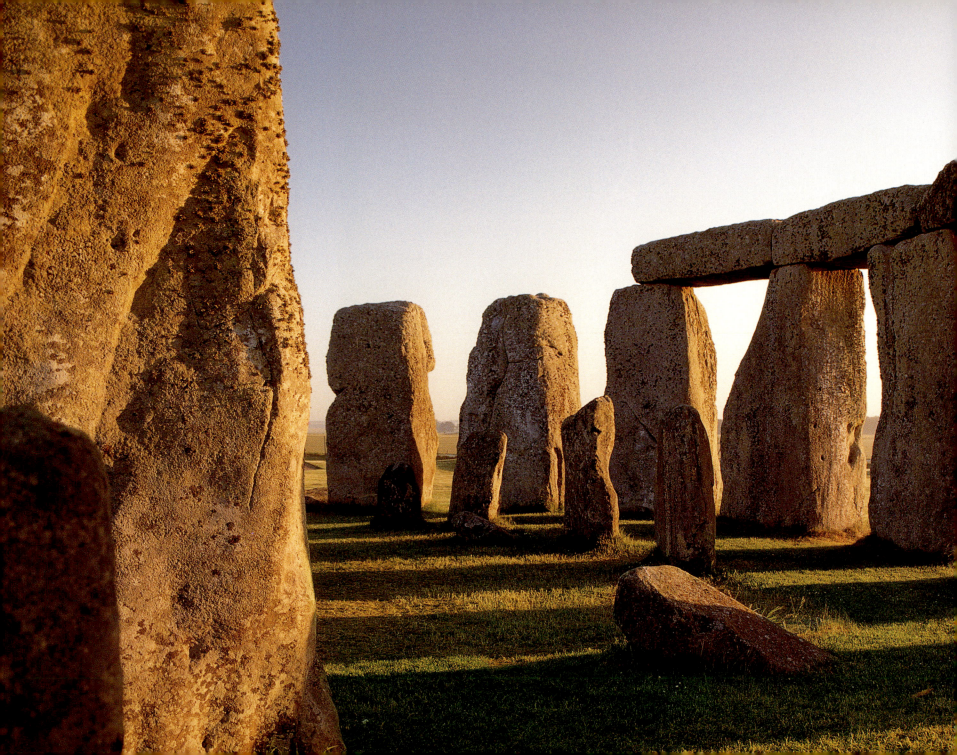

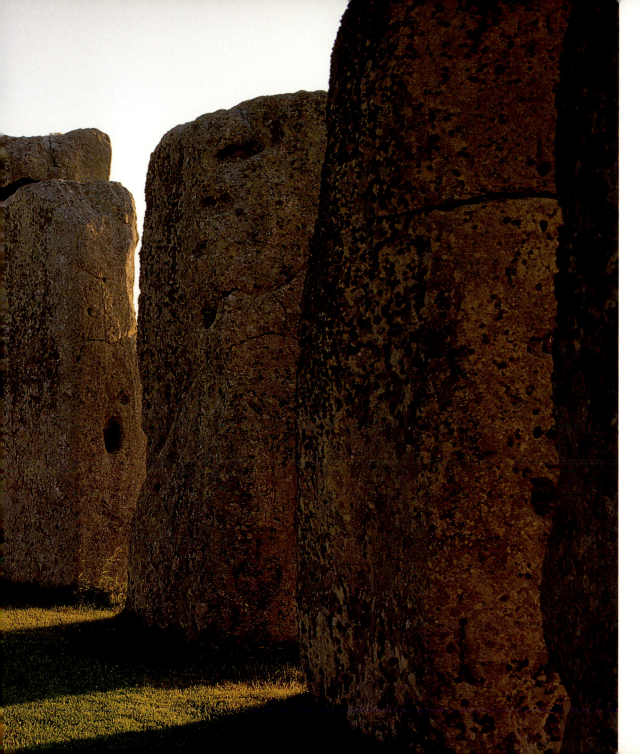

The sarsen circle and the
bluestone circle

A frosty early morning

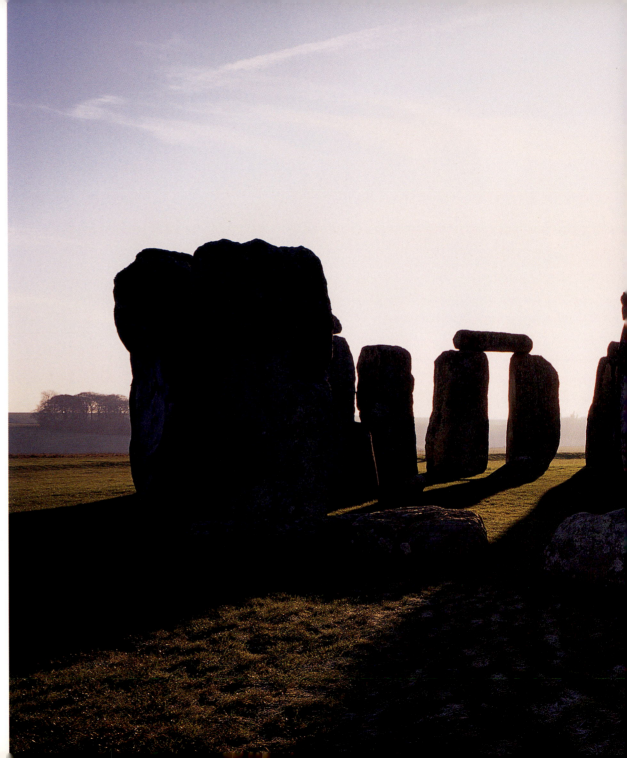

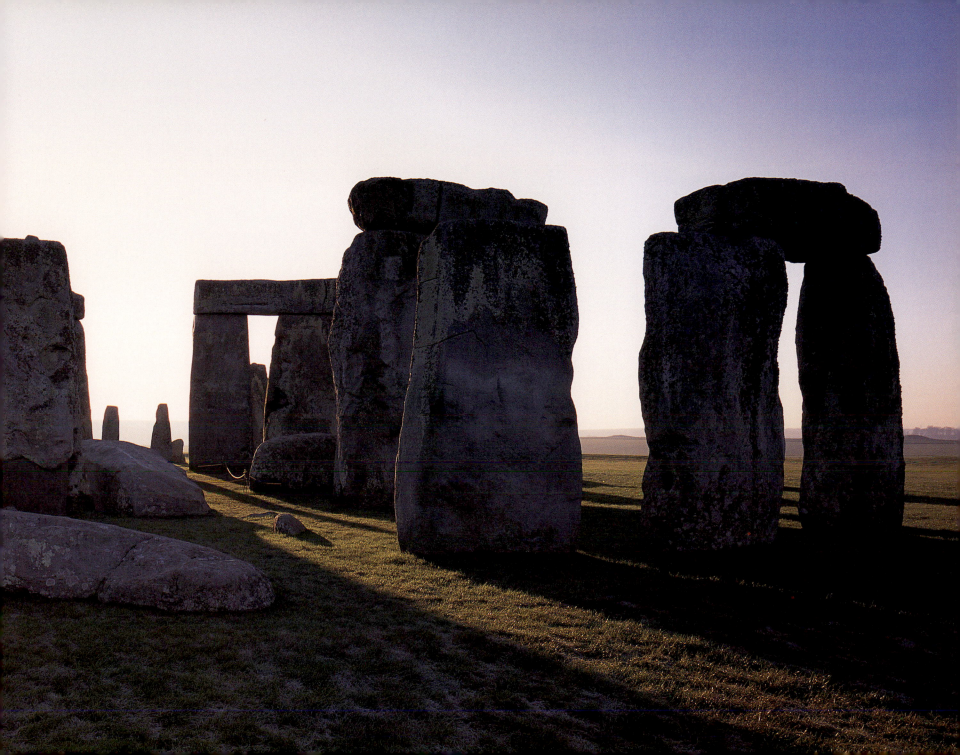

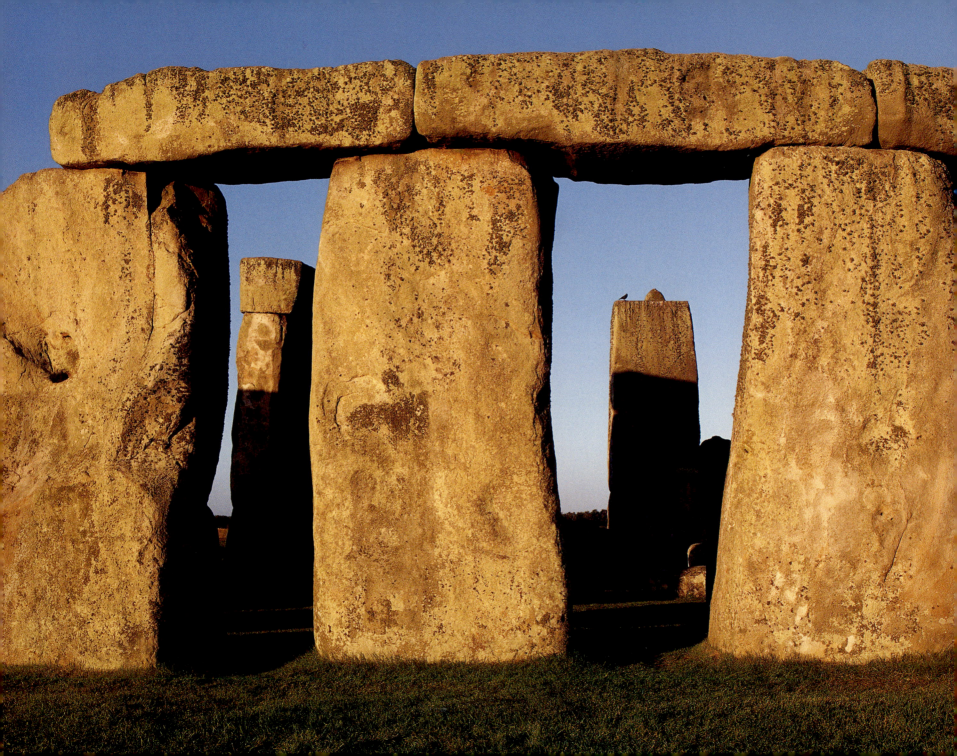

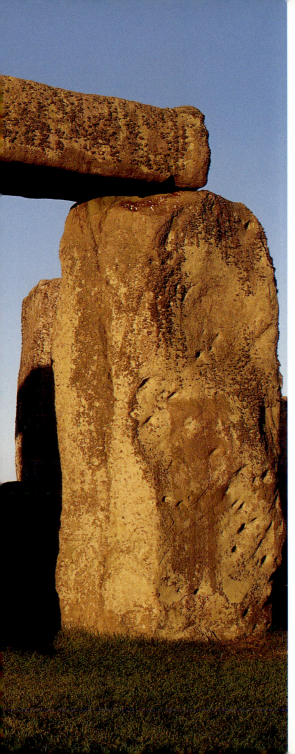

View of the sarsen circle
framing the only surviving
upright of the Great Trilithon

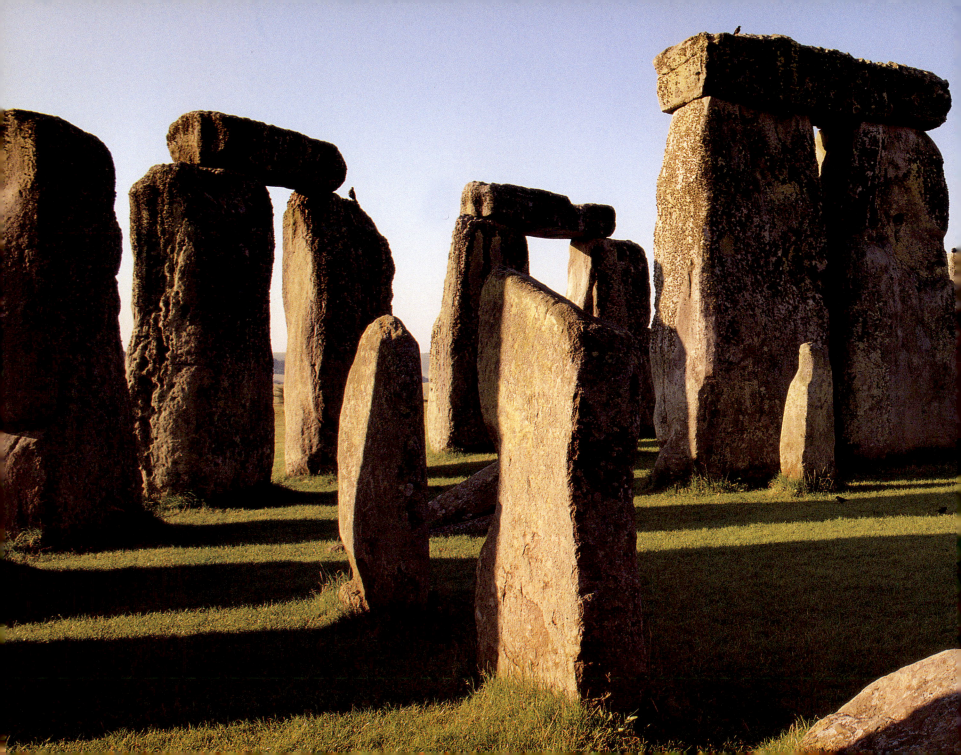

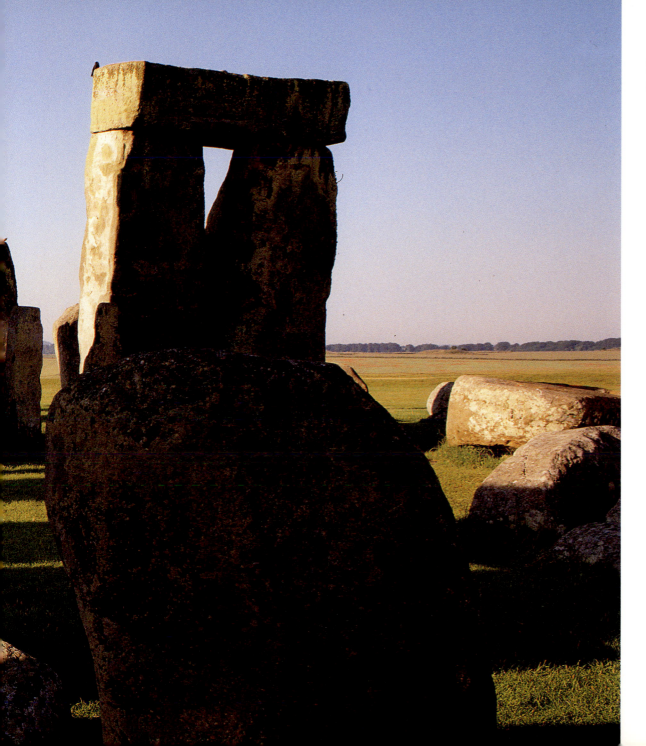

Sarsens and bluestones, standing and fallen

Long shadows inside the circle

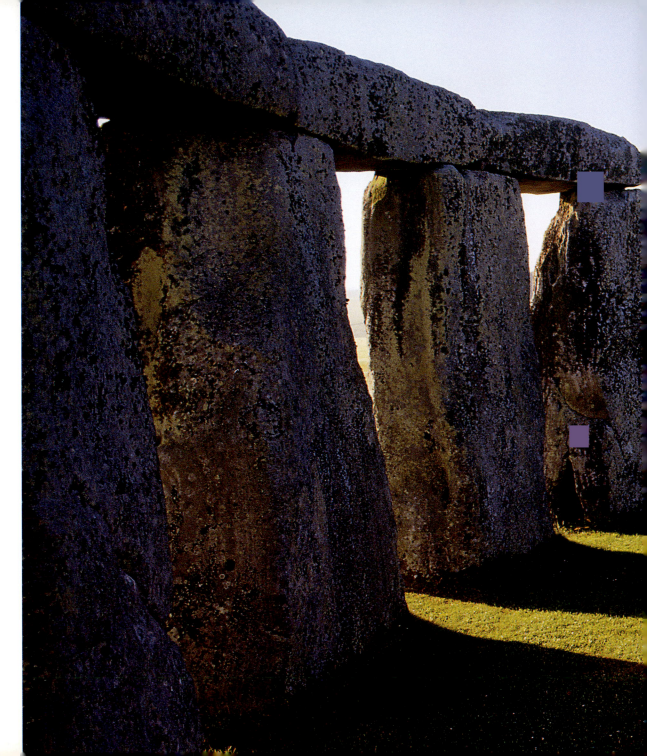

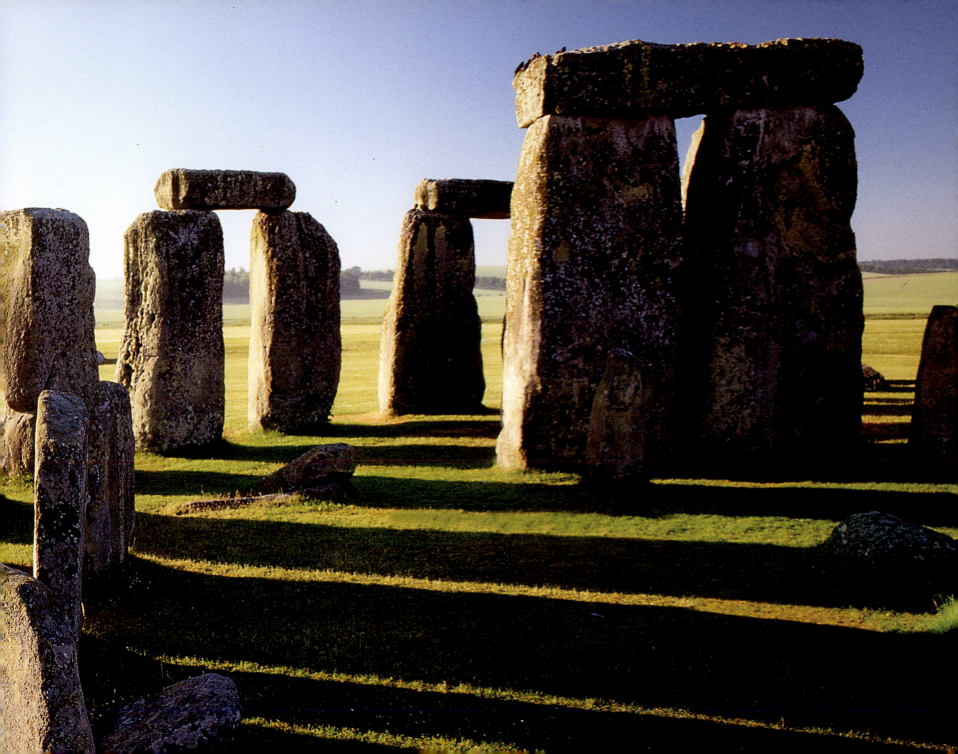

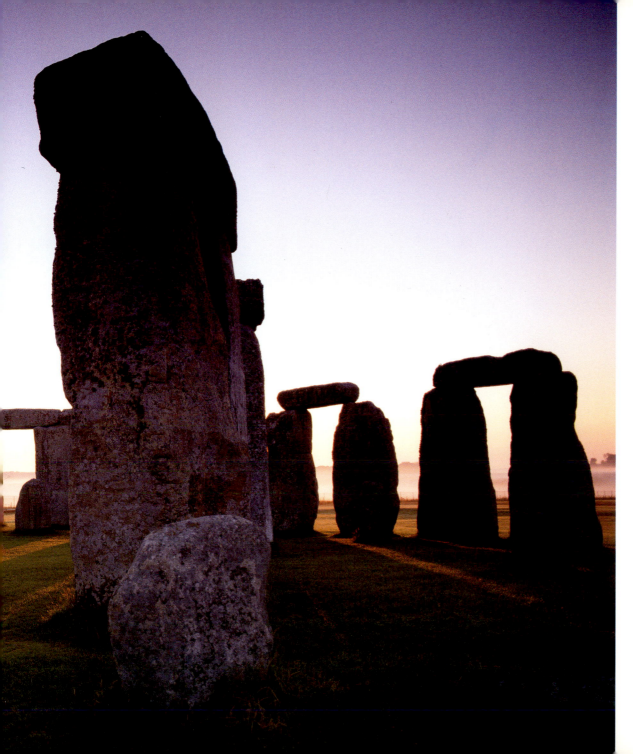

Among the stones at sunrise

The sarsen circle framing a trilithon
and bluestone

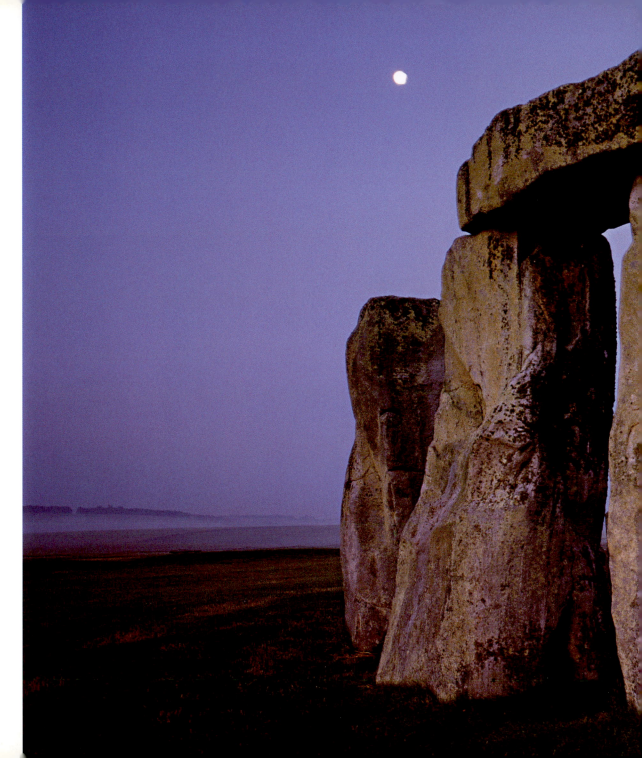

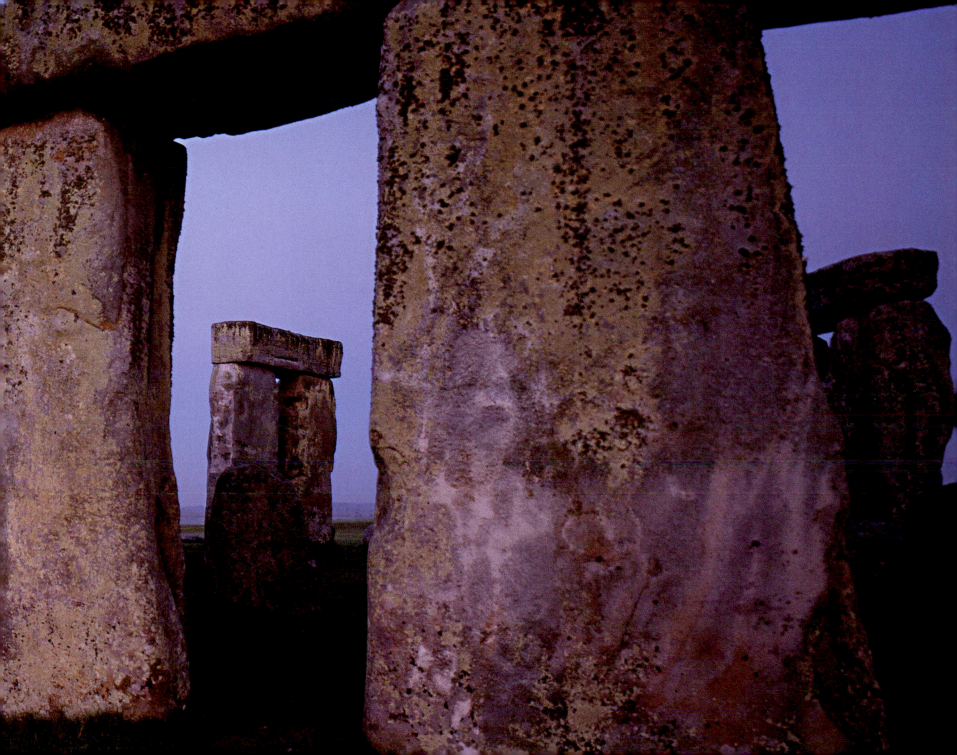

One of the three surviving trilithons

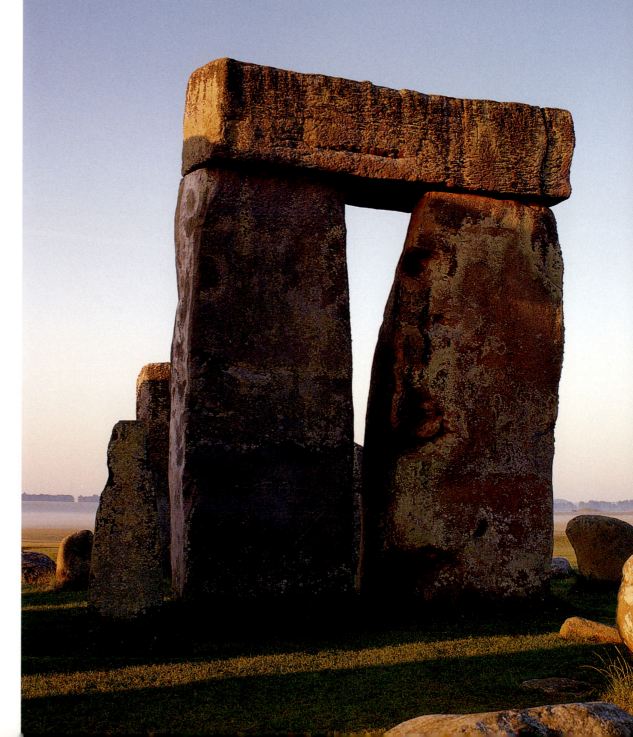

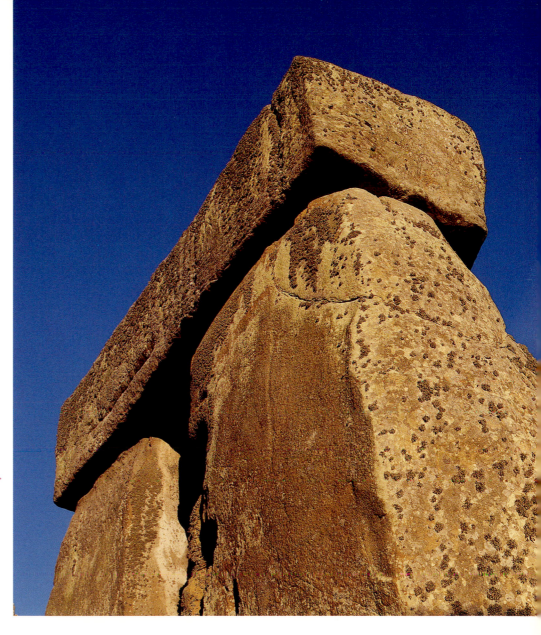

The massive lintel of
one of the sarsen
trilithons balanced on
its supporting uprights

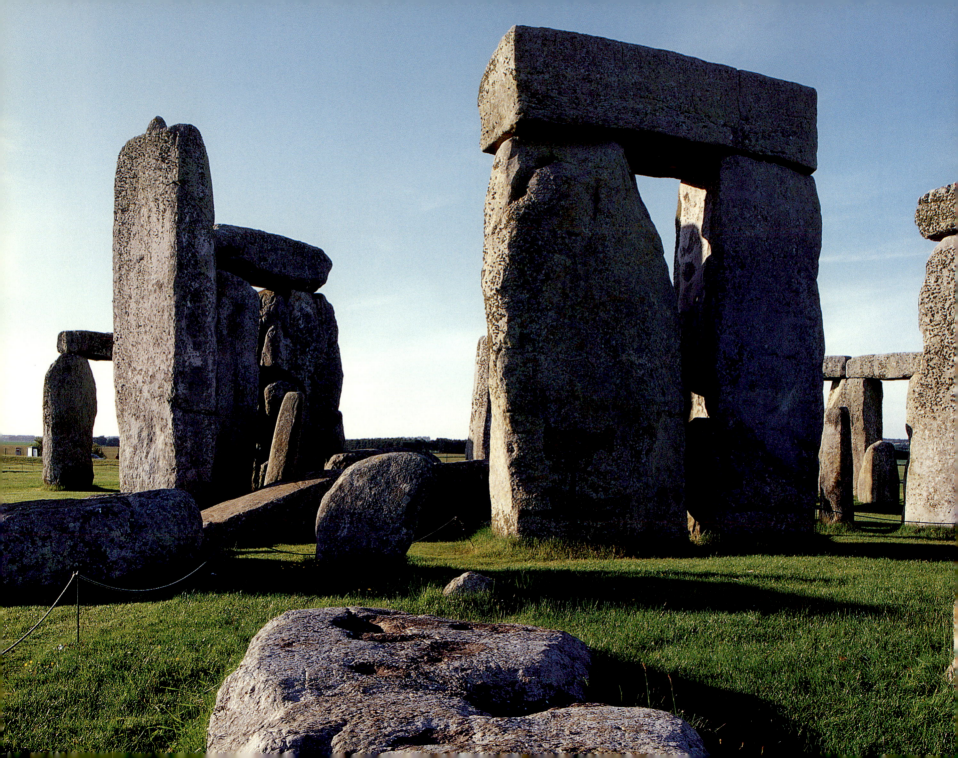

Inside the monument

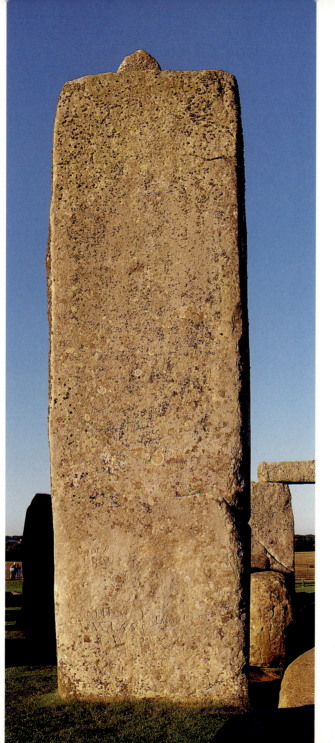

The sole surviving upright of the Great Trilithon – the tallest standing stone in the British Isles

Sarsen stones

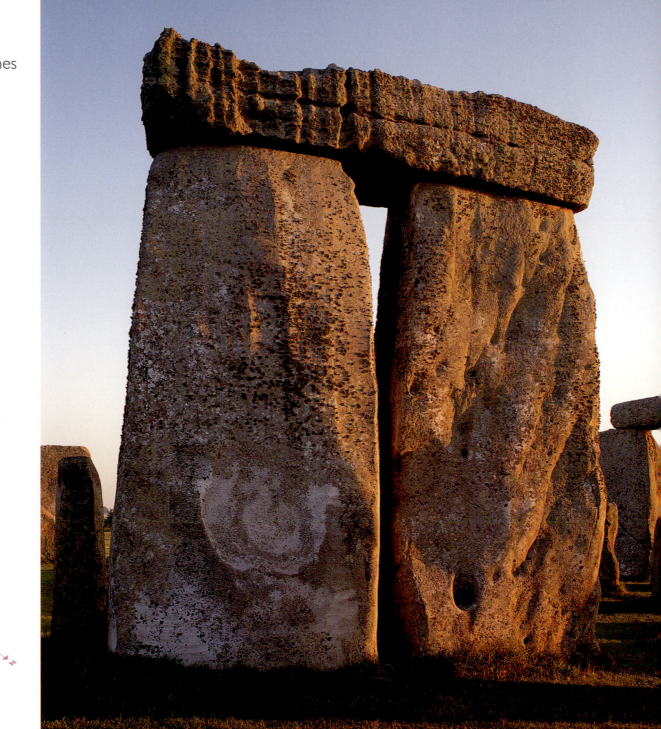

View from among the stones of a
fallen sarsen and the outer circle

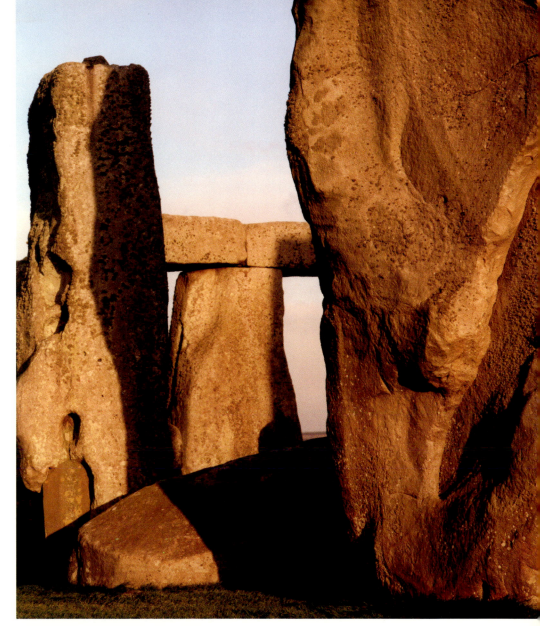

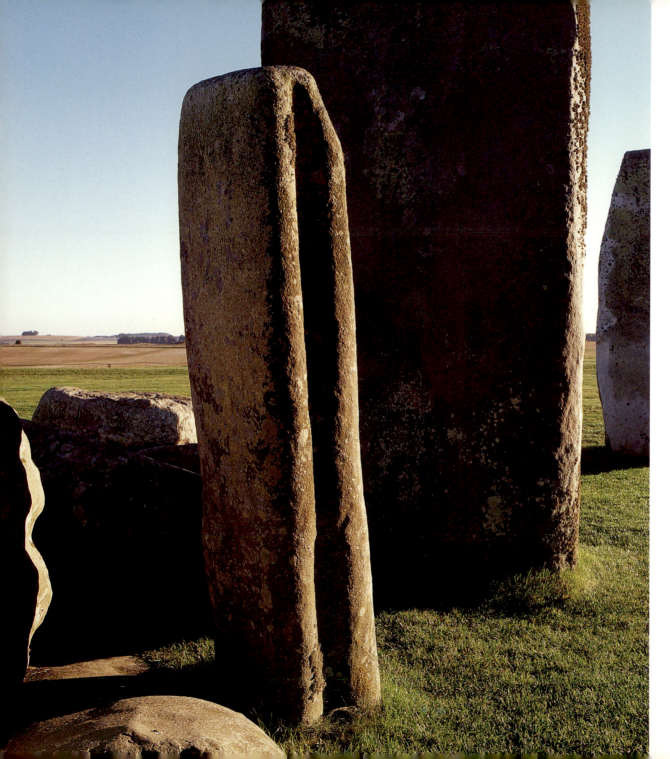

A finely shaped bluestone
from the inner bluestone
horseshoe

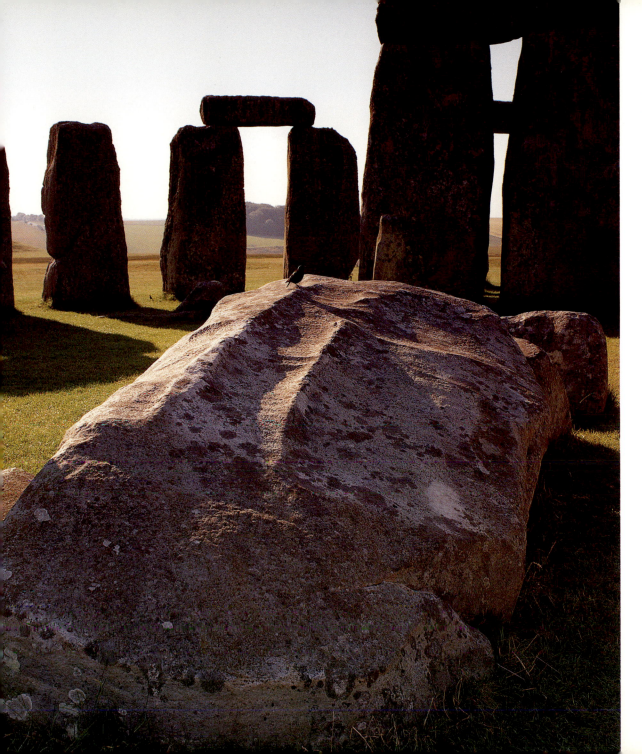

Tool marks on the back of a fallen sarsen upright – part of one of the trilithons

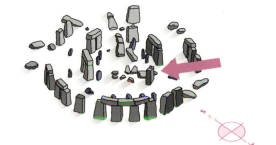

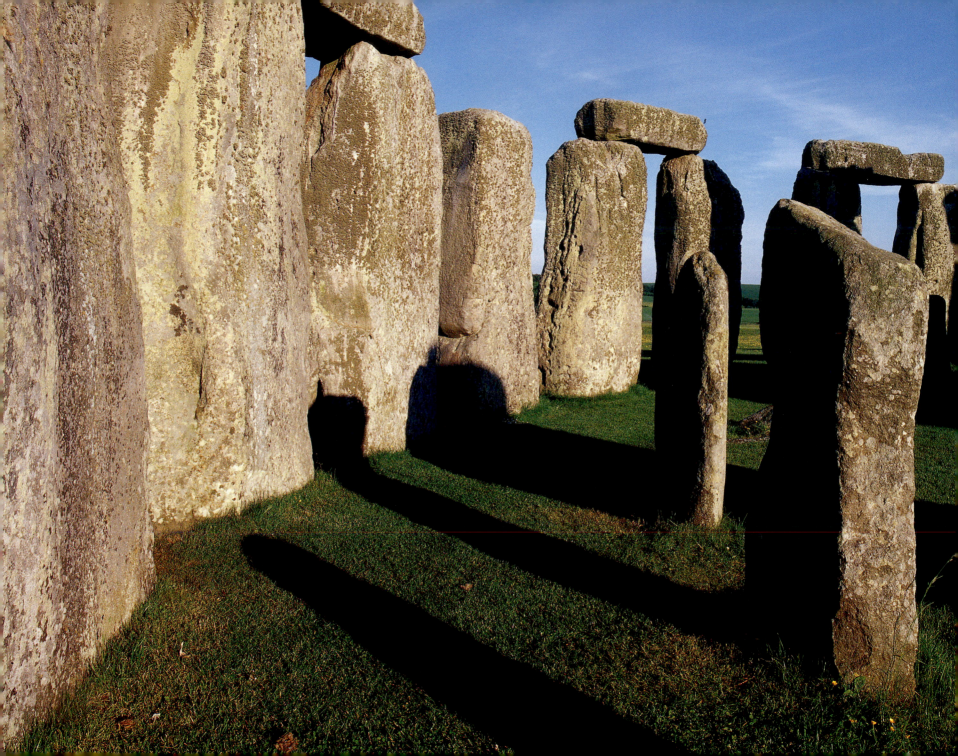

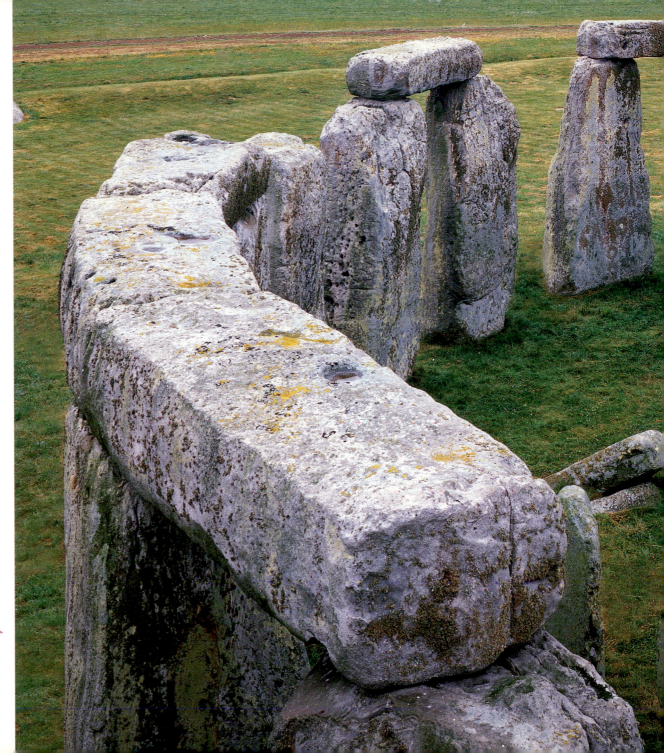

View from within the
stones showing the outer
sarsen circle with its
horizontal lintels and the
much smaller stones of the
bluestone circle

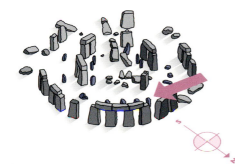

The elegantly curved and jointed
lintels of the sarsen circle

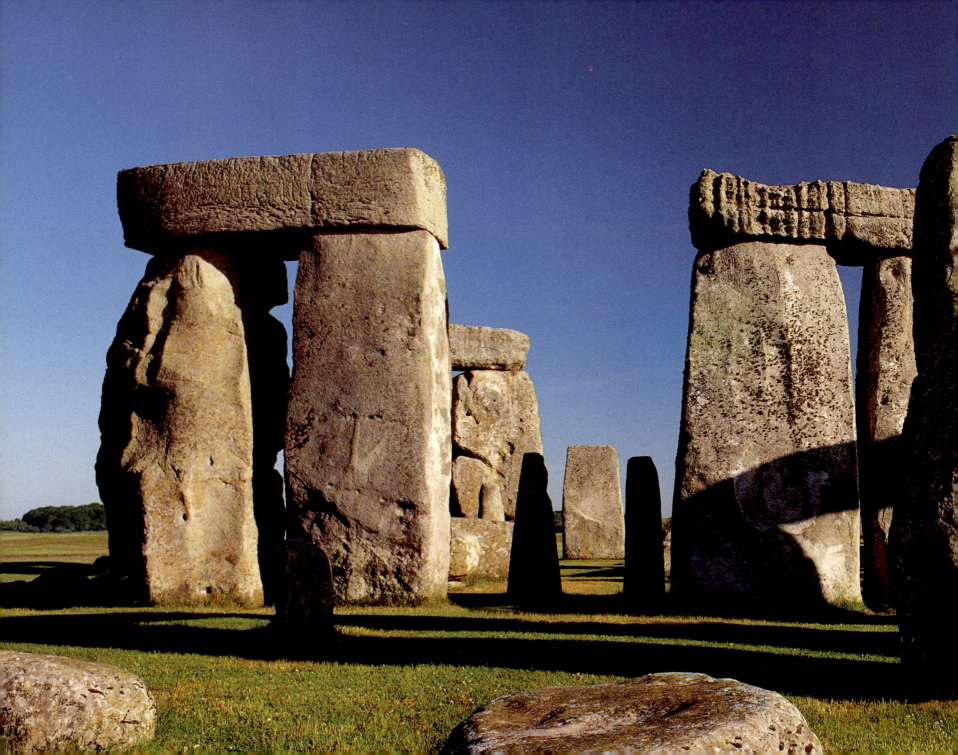

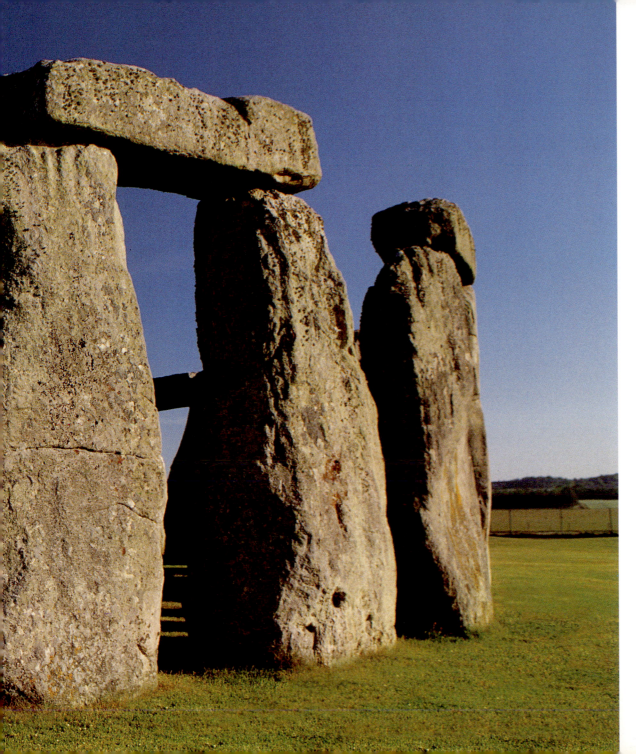

Standing and fallen stones

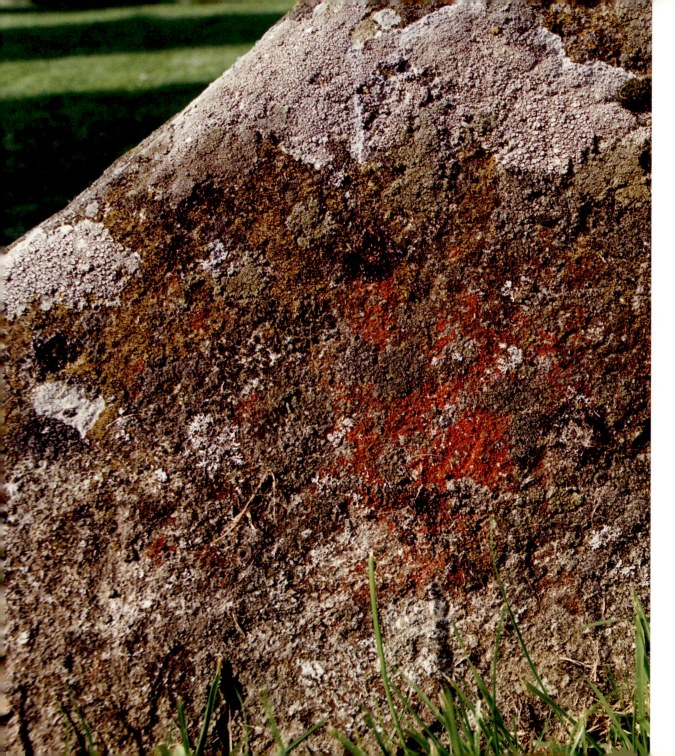

Lichen clothes many of the stones

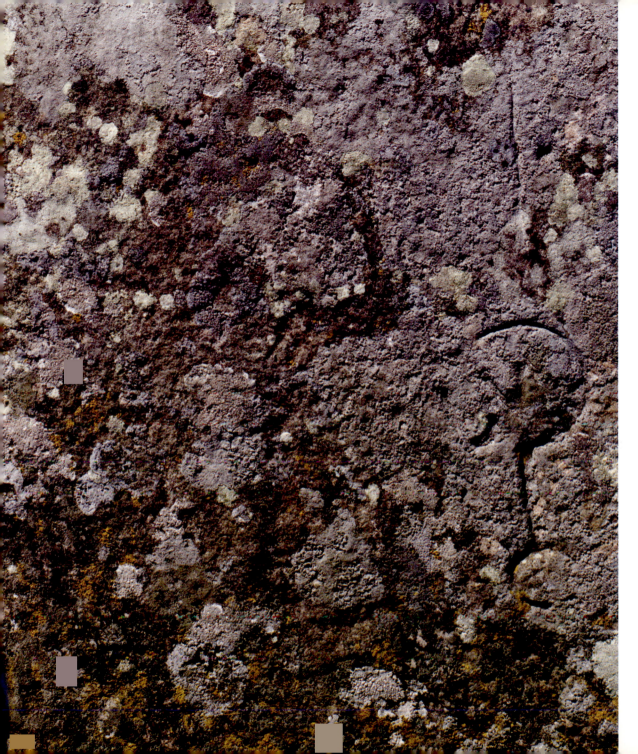

Rare lichen obscures
decoration carved on
the stones in
recent centuries

Lichen on stone

Graffiti on a sarsen trilithon representing Christopher Wren, who was born in the Wiltshire village of East Knoyle about 10 miles from Stonehenge

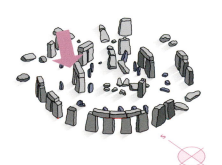

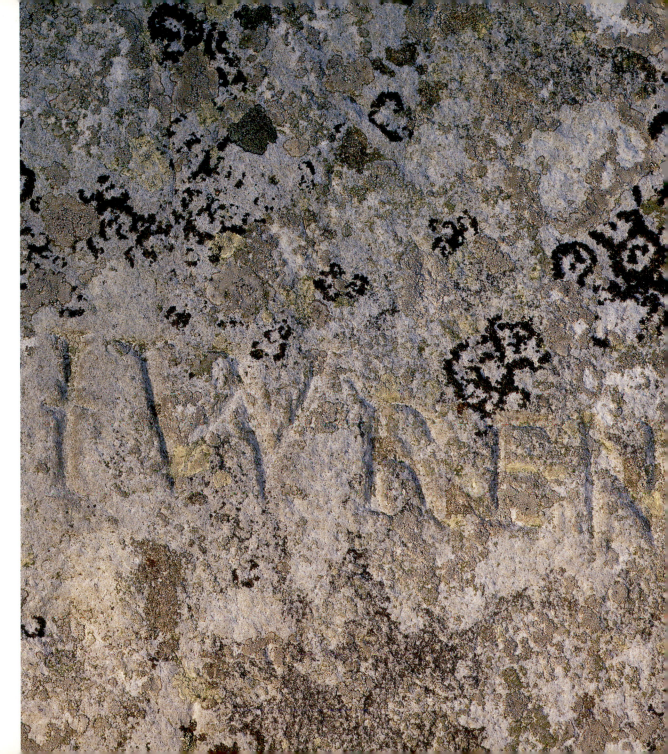

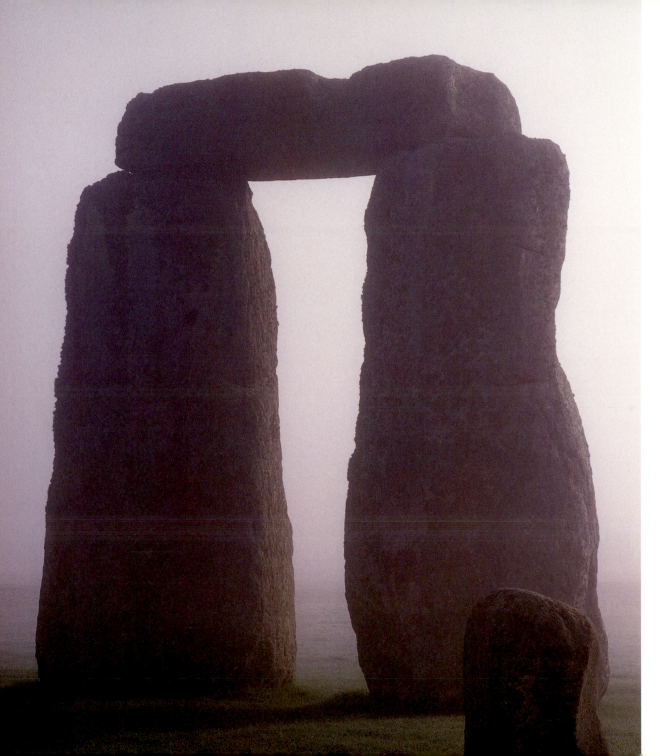

A fragment of the
sarsen circle

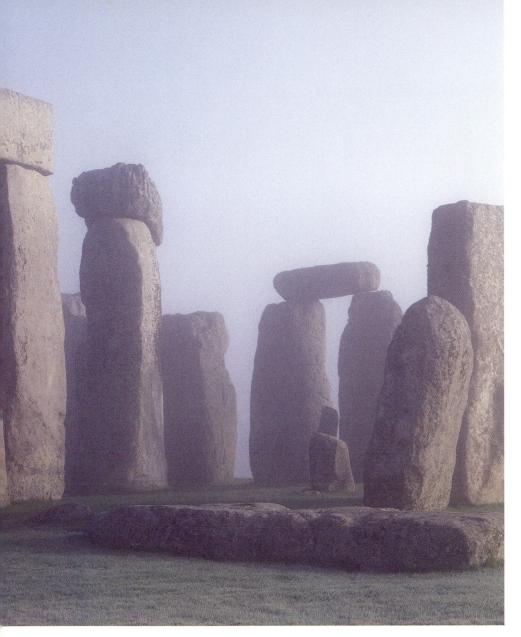

A misty morning at Stonehenge

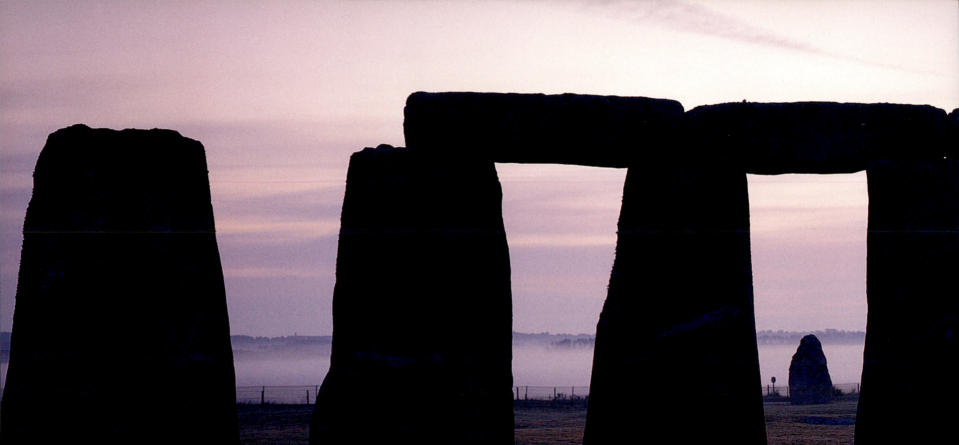

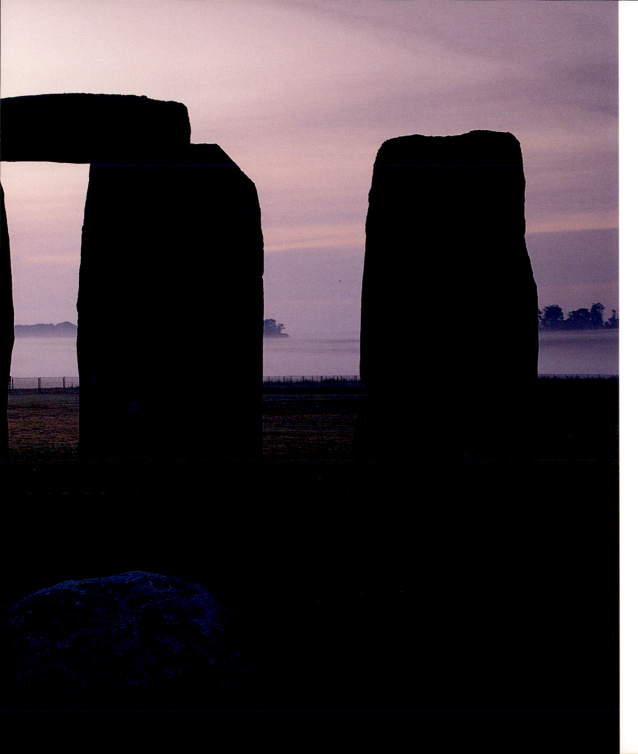

Early morning view of the centre of the stones, through part of the sarsen circle to the Heel Stone and beyond

The Heel Stone framed
by the stones of the
sarsen circle

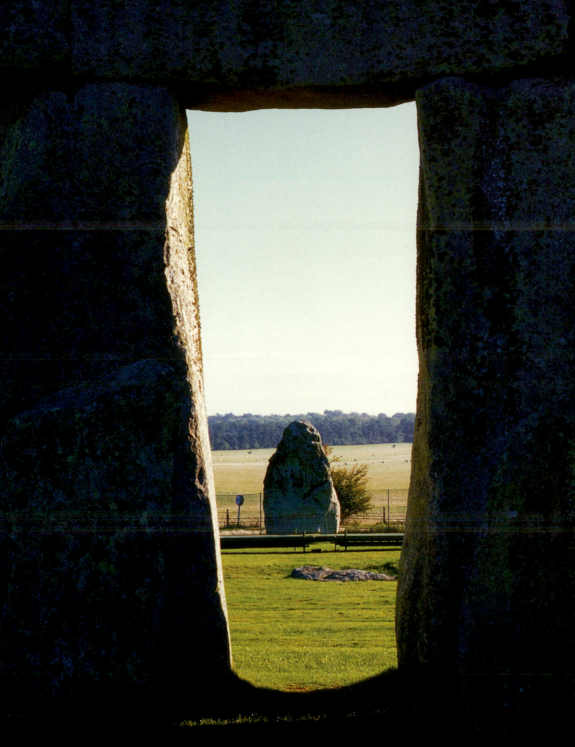

The ruins of the sarsen
circle in winter sunshine

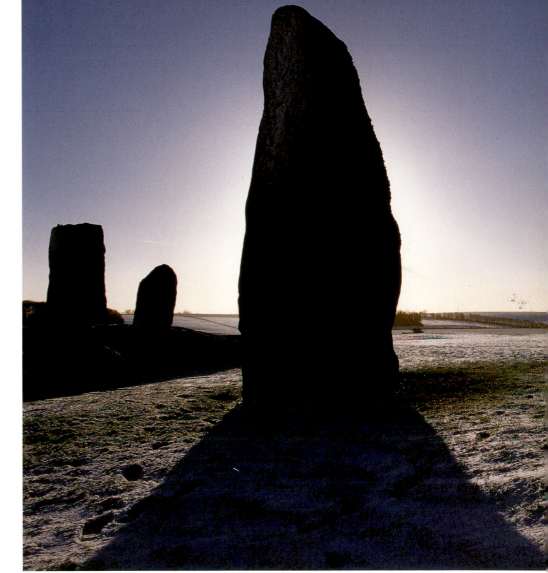

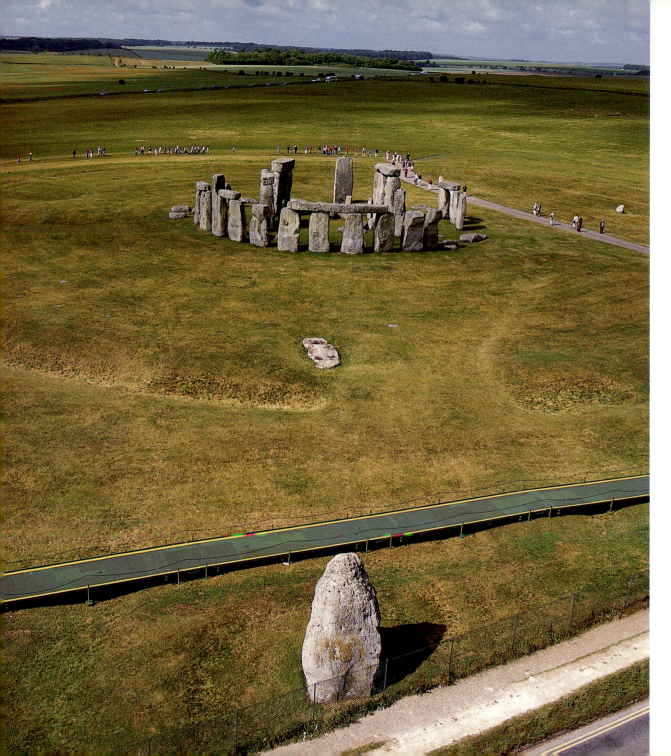

The Heel Stone in the foreground with the Slaughter Stone lying in the entrance to the earthwork enclosure that surrounds the stones

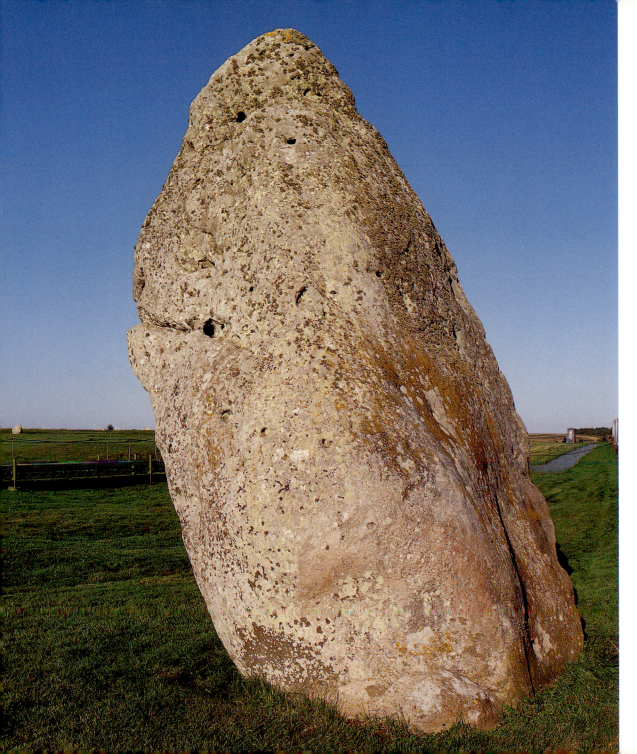

The Heel Stone

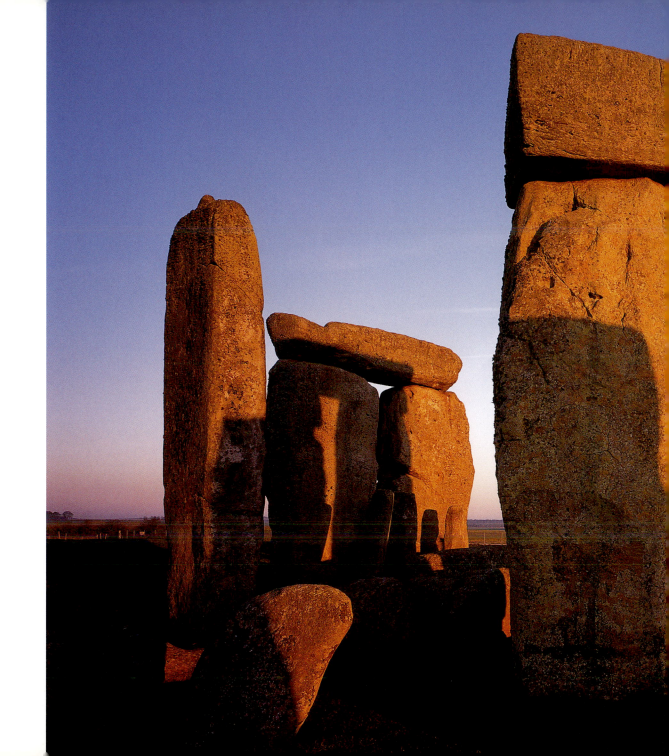

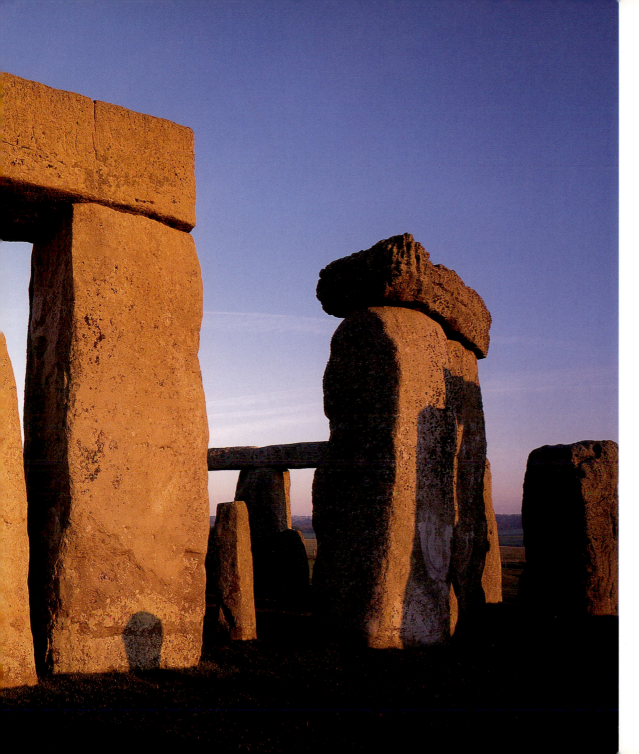

View at sunrise

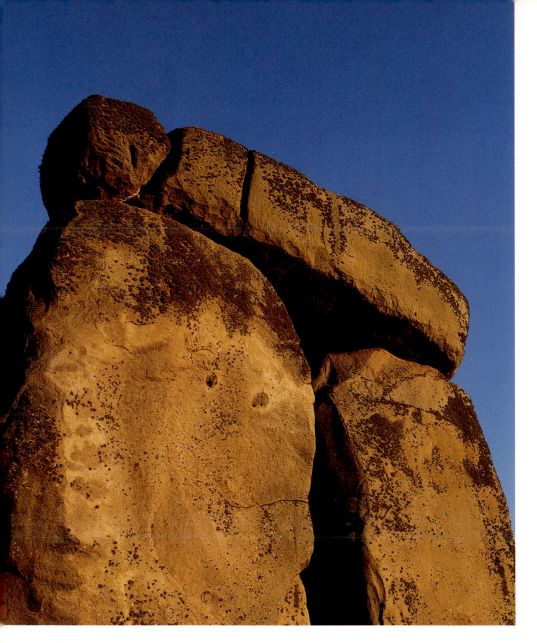

Lintel and uprights of
sarsen trilithon

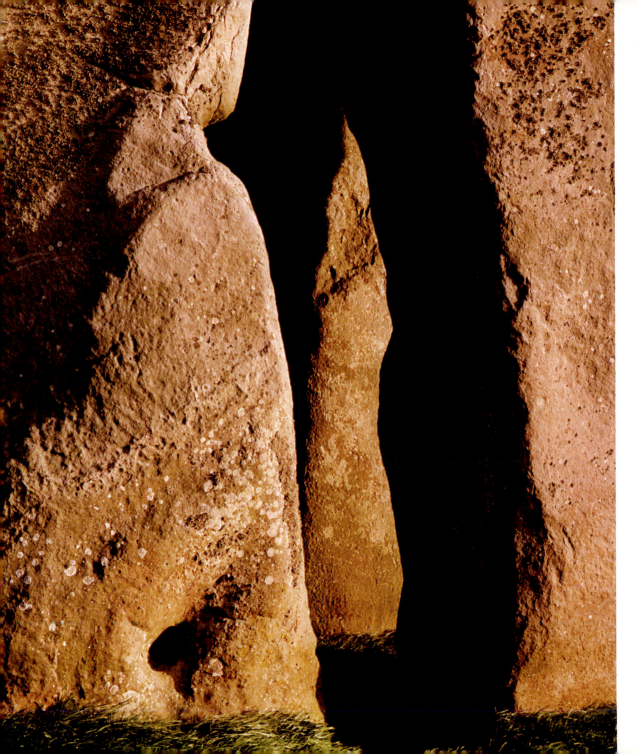

Close up of uprights of
sarsen trilithon

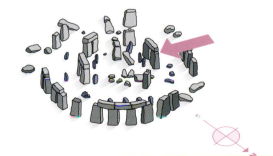

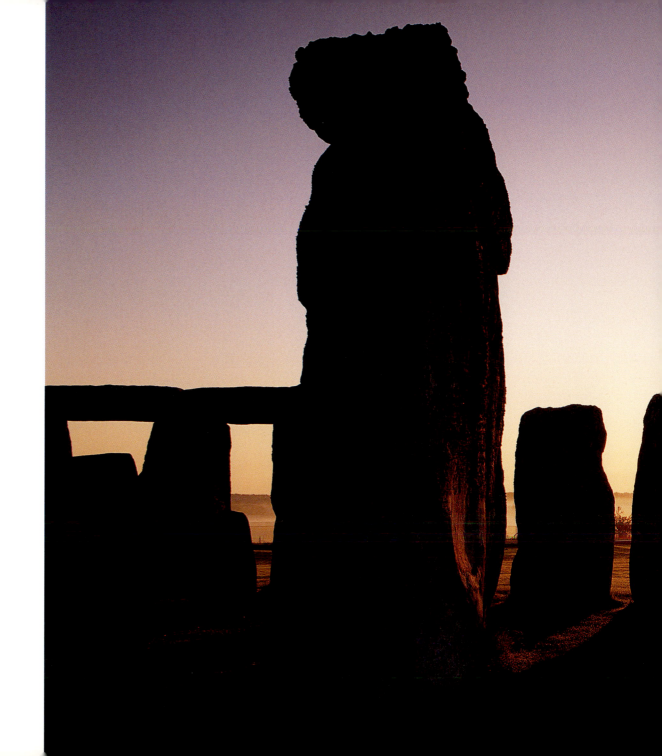

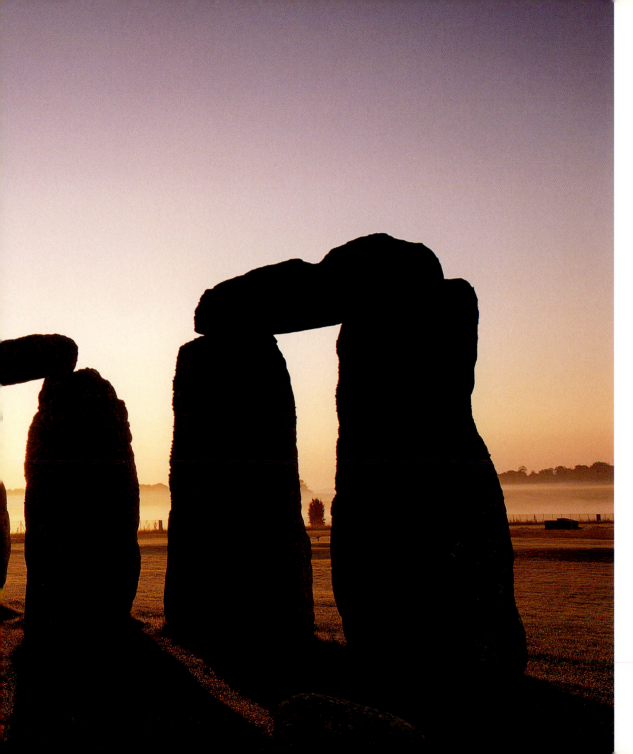

Silhouette of sarsen trilithon and
part of the sarsen circle at sunrise

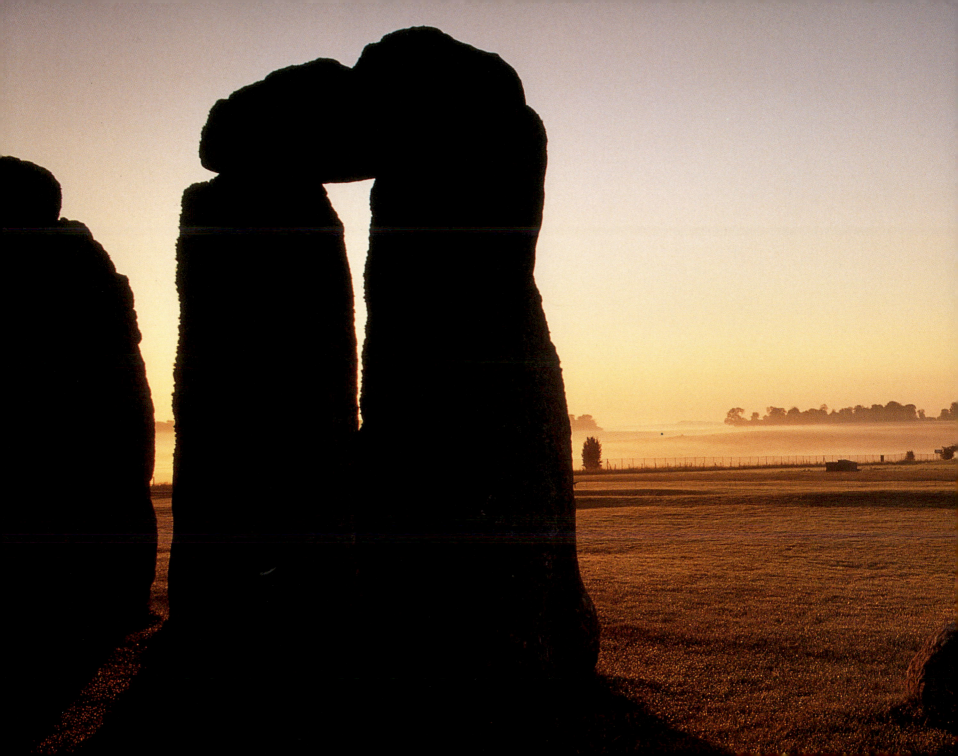

Looking out, over one of the
Station Stones to a Bronze Age
burial mound

Sunrise, looking out through the sarsen circle

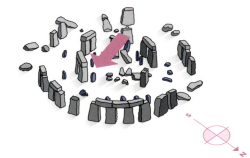

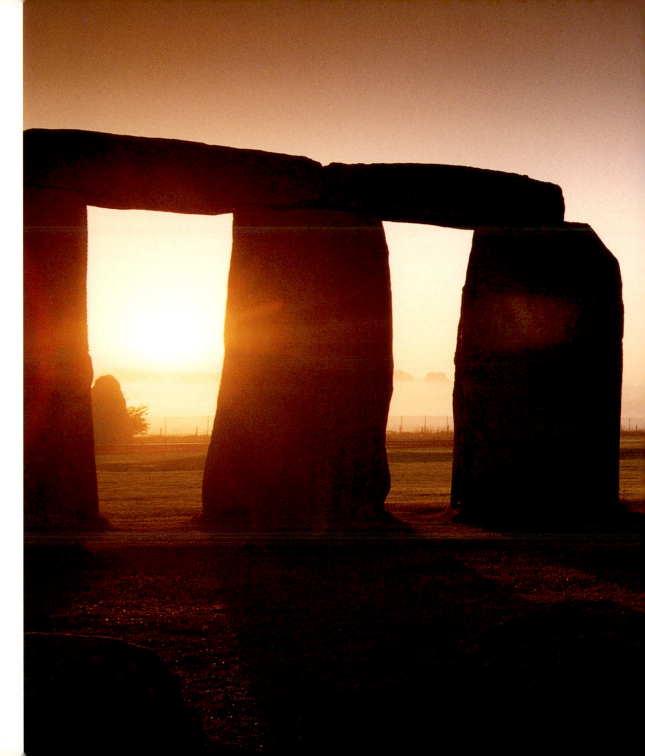

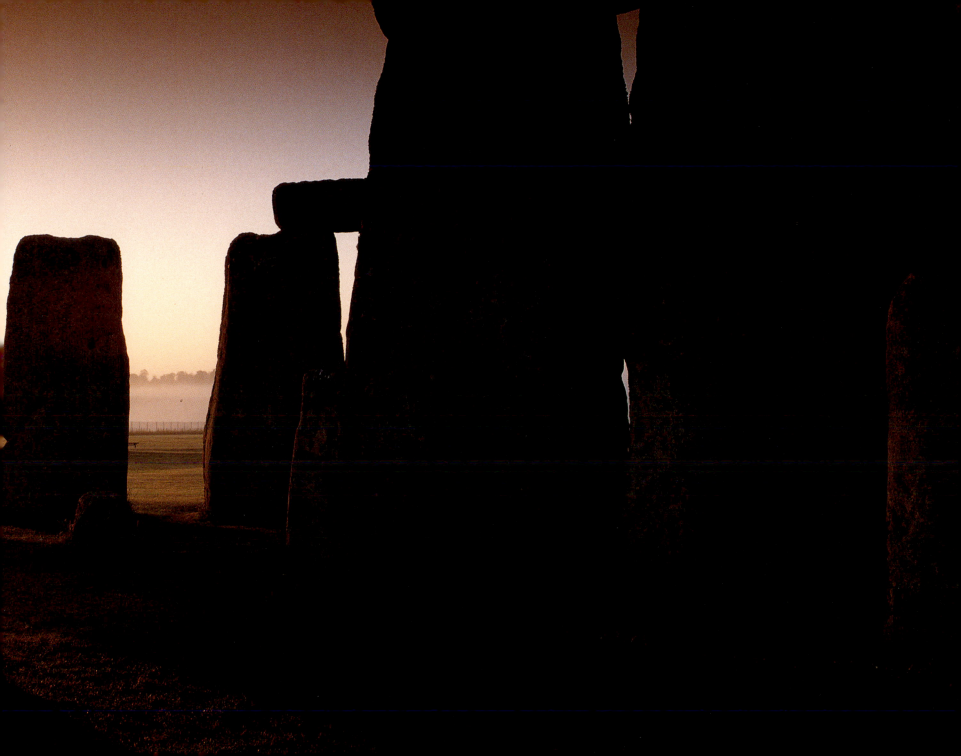

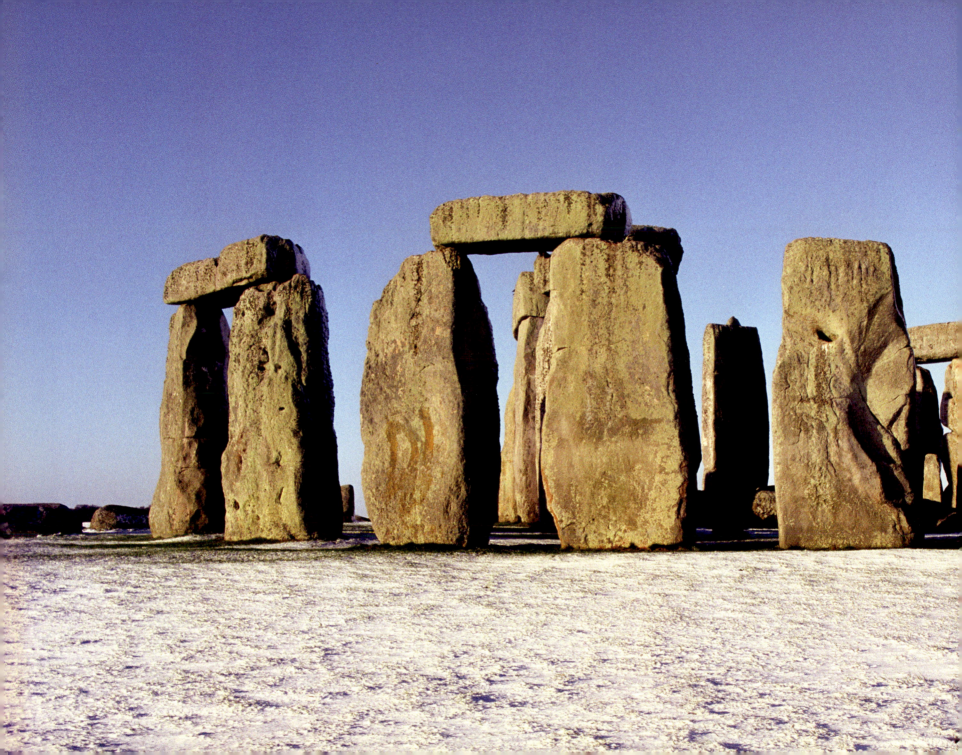

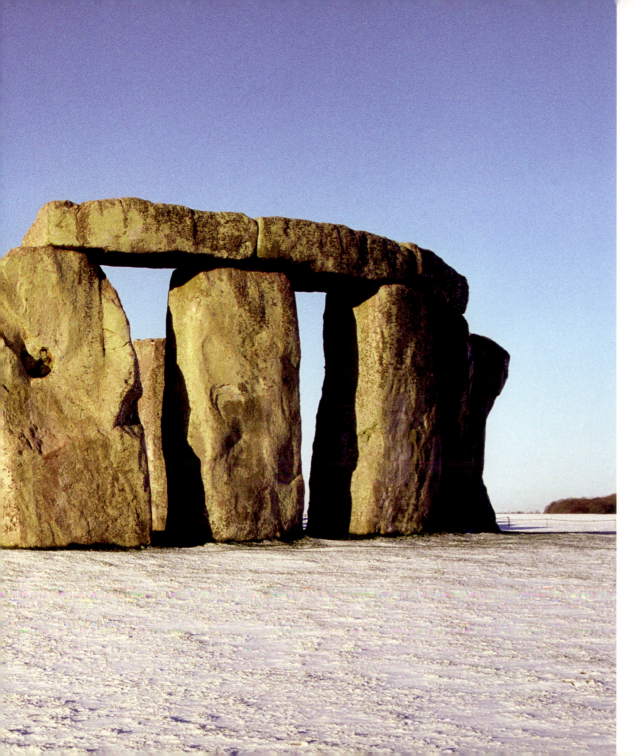

General view in winter

Frost and mist in the early morning

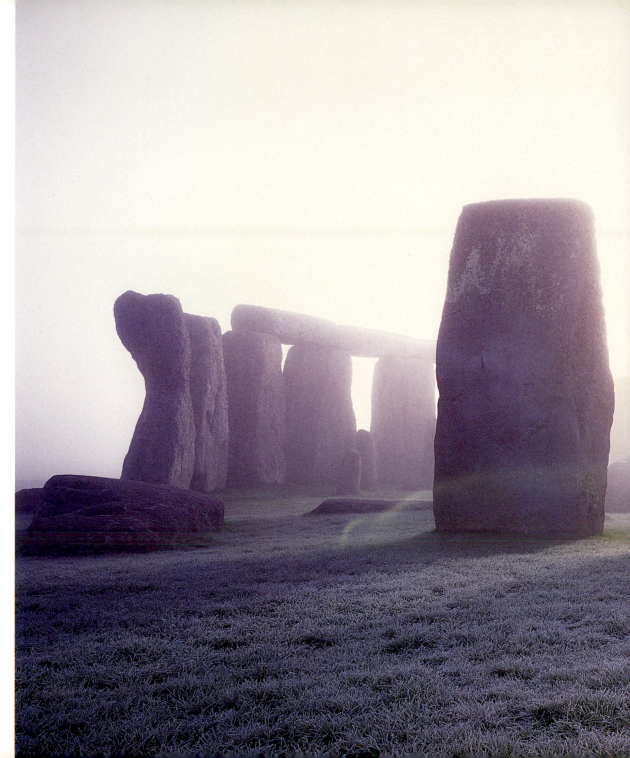

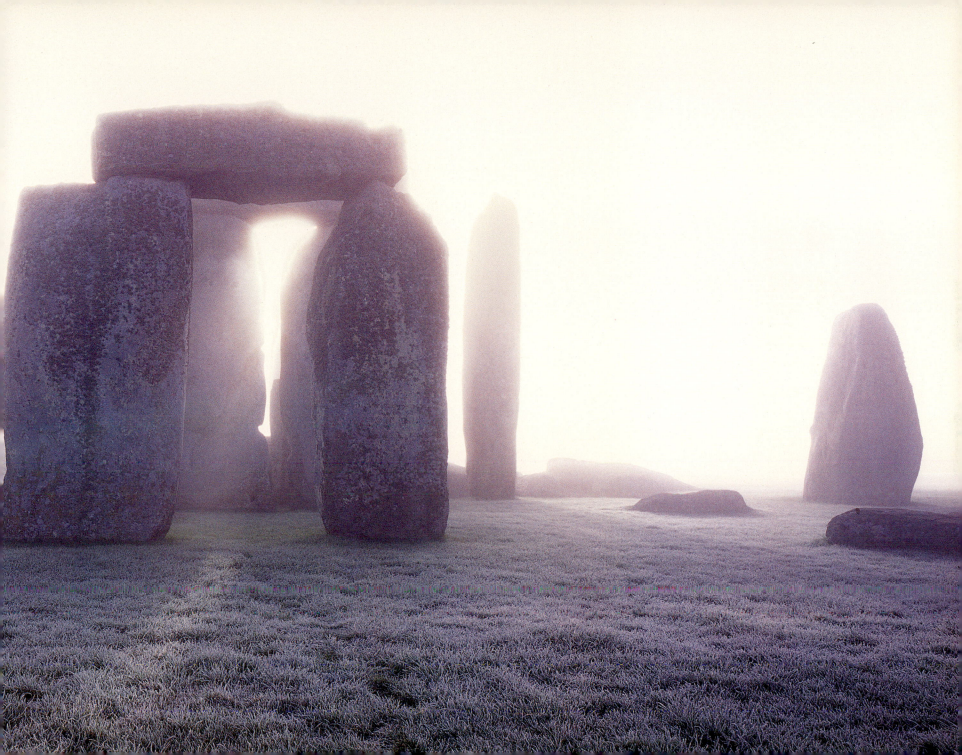

The stones clothed in snow

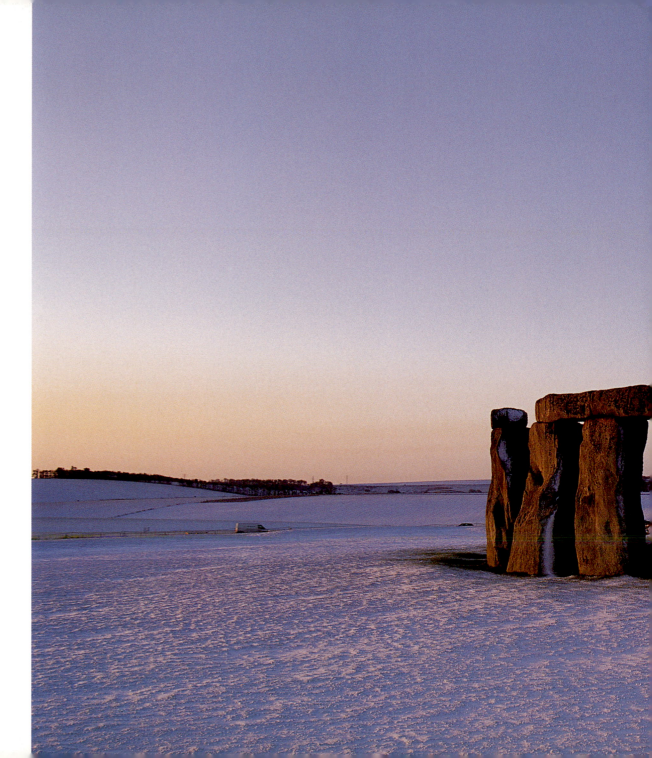

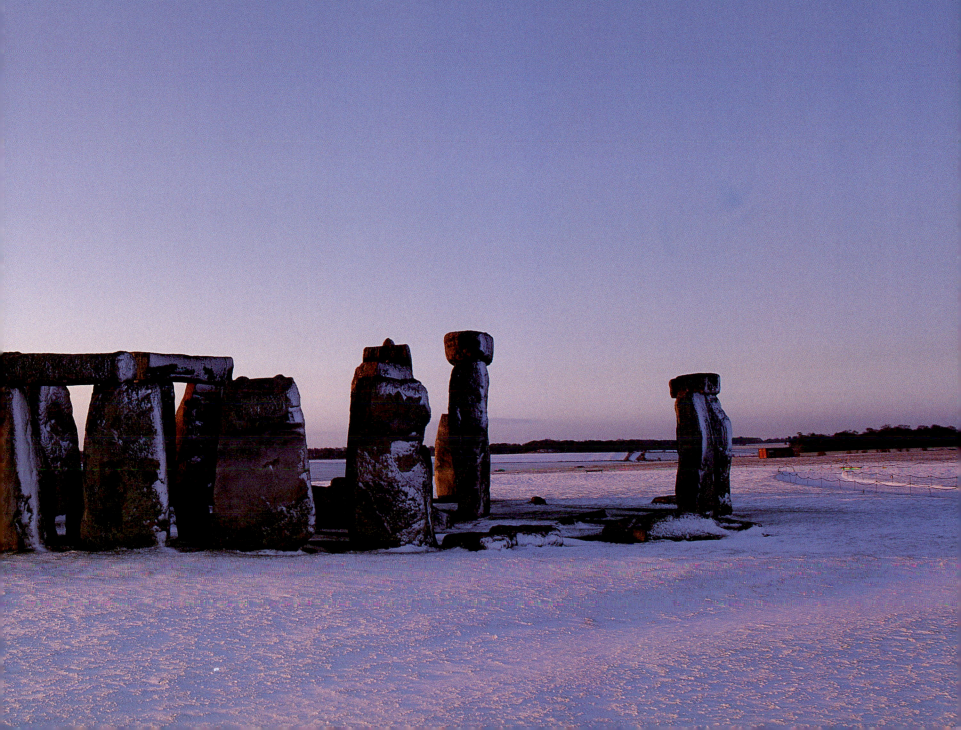

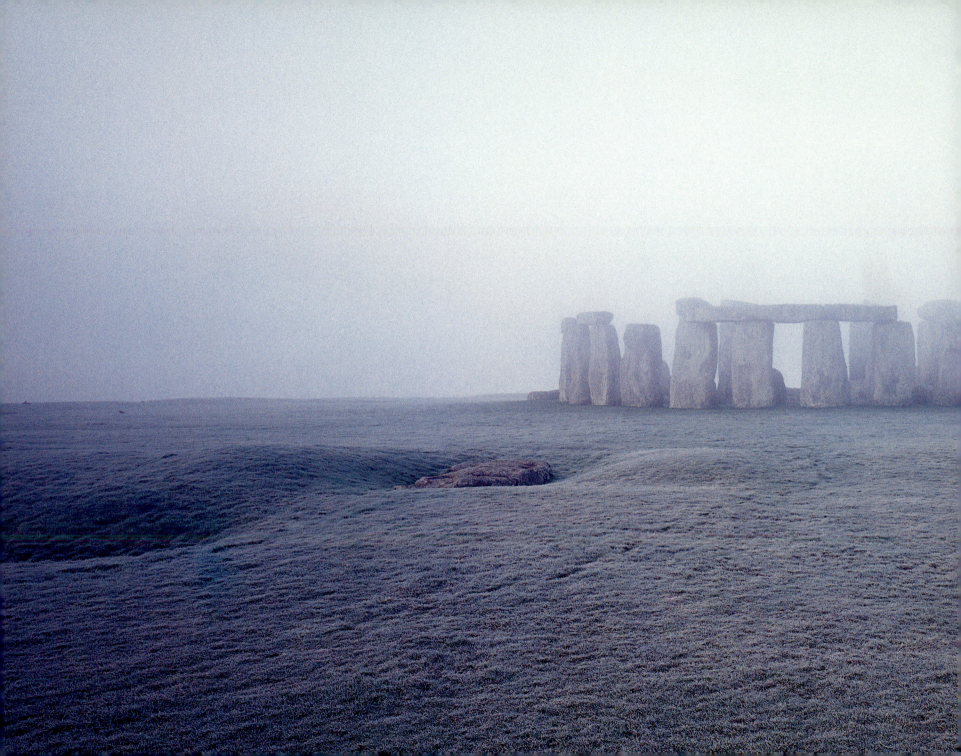

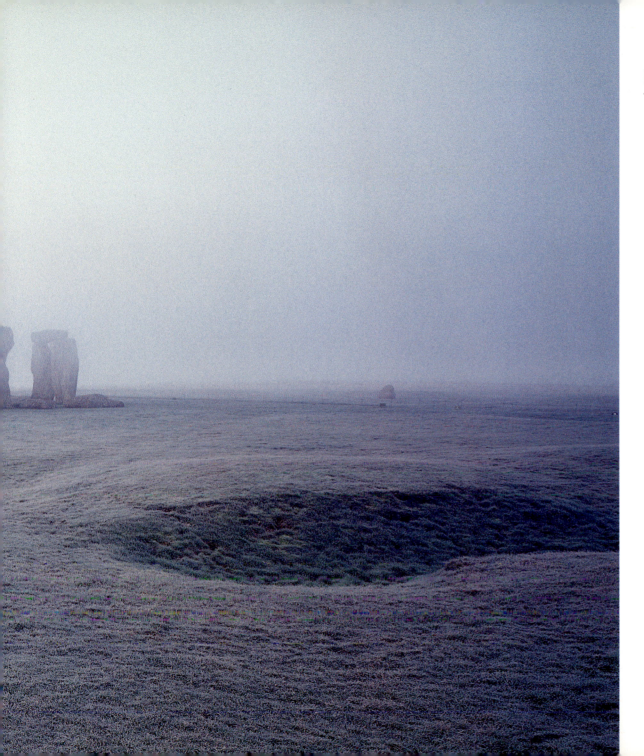

Misty view through the entrance
to the enclosure

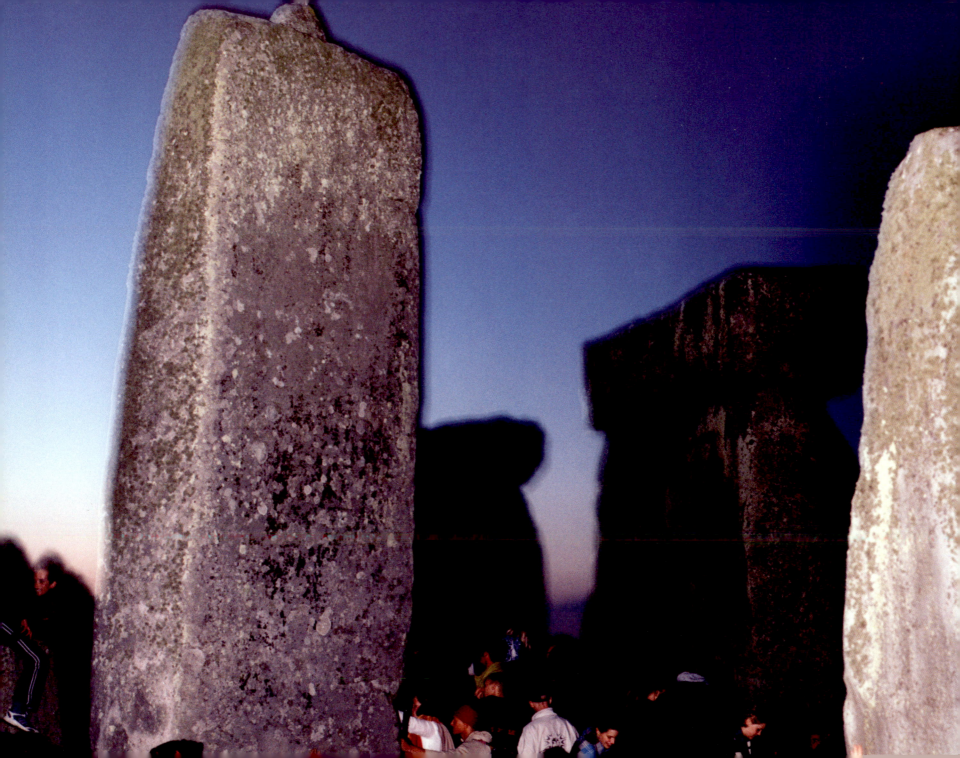

The interior at the summer solstice

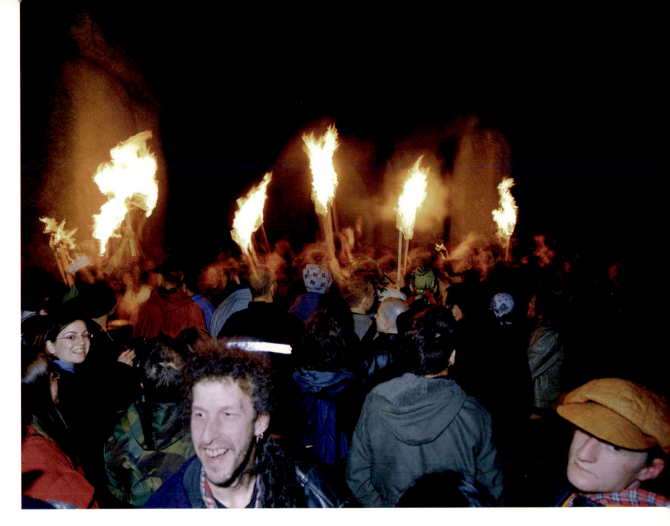

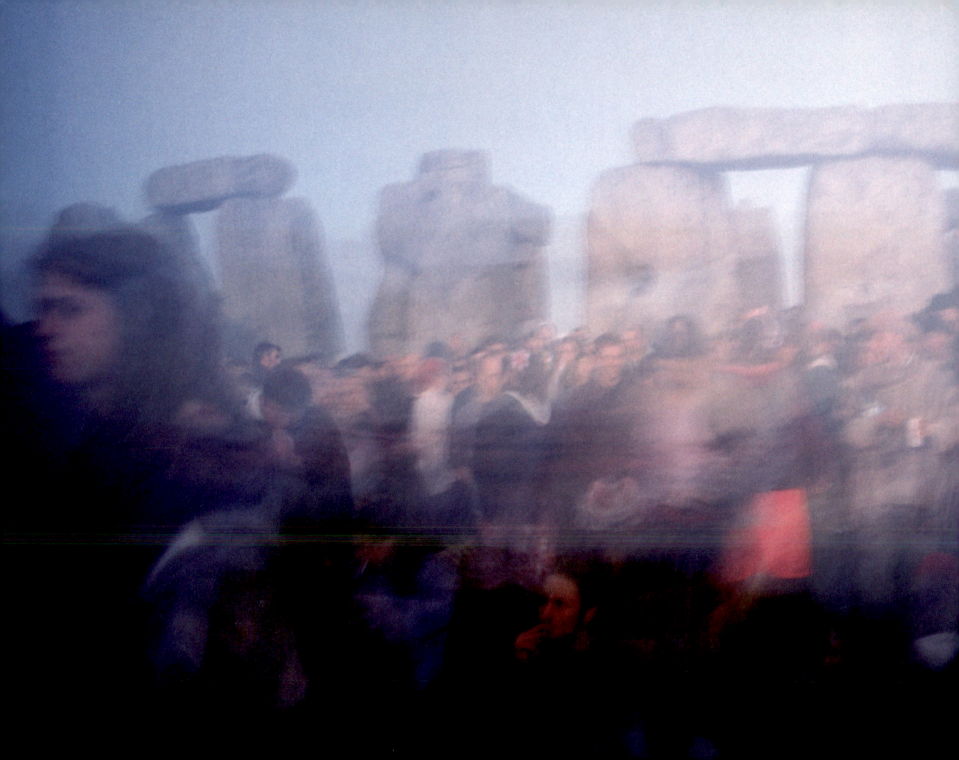

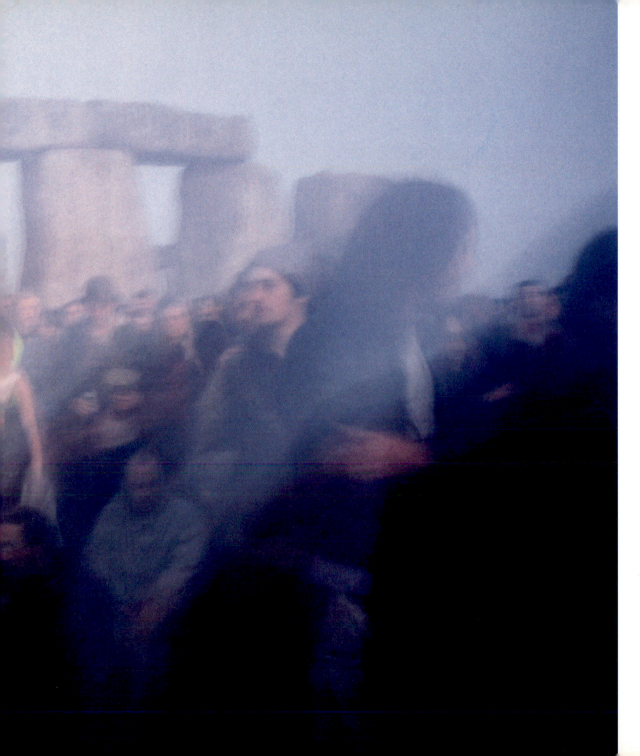

Summer solstice celebrations
outside the stones

Photography:

James Davies: p4/5, p6/7, p8, p18/19, p22/23, p26/27, p30/31, p32/33, p34/35, p38/39, p40/41, p51, p52/53, p55, p56, p57, p58, p62, p63, p64, p65, p66, p67, p70, p71, p73, p74/75, p76, p77, p84/85, p86/87, p88/89, p90/91, p92/93, p94/95

Nigel Corrie: p14/15, p16/17, p20/21, p28/29, p36/37, p42/43, p44/45, p46/47, p48/49, p50, p54, p60/61, p78/79, p 80/81, p 82/83

Charlie Waite: p9

Paul Highnam: p68/69

Sky Eye Aerial Photography: p10/11, p12/13, p72

English Heritage Photo Library: p24/25, p59